FEDERICO ZERI (Rome, 1921-1998), eminent art historian and critic, was vice-president of the National Council for Cultural and Environmental Treasures from 1993. Member of the Académie des Beaux-Arts in Paris, he was decorated with the Legion of Honor by the French government. Author of numerous artistic and literary publications; among the most well-known: *Pittura e controriforma*, the Catalogue of Italian Painters in the Metropolitan Museum of New York and the Walters Gallery of Baltimore, and the book *Confesso che ho sbagliato*.

Work edited by FEDERICO ZERI

Text
based on the interviews between
FEDERICO ZERI and MARCO DOLCETTA

This edition is published for North America in 1999 by NDE Publishing*

Chief Editor of 1999 English Language Edition
ELENA MAZOUR (*NDE Publishing**)

English Translation
ADAM VICTOR FOR SCRIPTUM S.R.L.

Realisation
CONFUSIONE s.r.l., ROME

Editing
ISABELLA POMPEI

Desktop Publishing
SIMONA FERRI, KATHARINA GASTERSTADT

ISBN 1-55321-008-5

Illustration references

Bridgeman/Alinari: 12br, 14tr, 22-23, 29, 34, 42tl, 45/VIII-IX.

Giraudon/Alinari archives: 1, 2-3, 4t-b, 4-5, 6b, 7, 9l-r, 10-11, 11, 12l-tr, 13, 14b, 15, 18-19, 32tl, 38-39, 40t, 44/III-X-XI-XII, 45/XIV.

Luisa Ricciarini Agency: 8t, 19b, 30t-b, 36b, 41tr, 44/VII, 45/IV.

RCS Libri Archives: 6t, 14tl, 16t, 17, 21, 22t-b 24, 25, 26, 26-27, 28b, 30-31, 39, 40bl, 44/I-II-IV-VI-VIII-IX, 45/I-VII.

R.D.: 2, 8b, 16b, 19t, 20 t-b, 28t 32tr-b, 33, 35, 36tl-tr, 37, 40br, 41r, 42tr-b, 43, 44/V, 45/II-III-V-VI-X-XI-XII-XIII.

Printed and bound by Poligrafici Calderara S.p.A., Bologna, Italy

* a registered business style of NDE Canada Corp.
 18-30 Wertheim Court, Richmond Hill, Ontario
 L4B 1B9 Canada, tel. (905) 731-12 88

The captions of the paintings contained in this volume include, beyond just the title of the work, the dating and location. In the cases where this data is missing, we are dealing with works of uncertain dating, or whose current whereabouts are not known. The titles of the works of the artist to whom this volume is dedicated are in blue and those of other artists are in red.

RENOIR

MOULIN DE LA GALETTE

Renoir "is the only great painter who never painted a sad painting," wrote Octave Mirbeau in 1913. The MOULIN DE LA GALETTE is the finest example of his radiant outlook. It is an anthem to youth and hap-

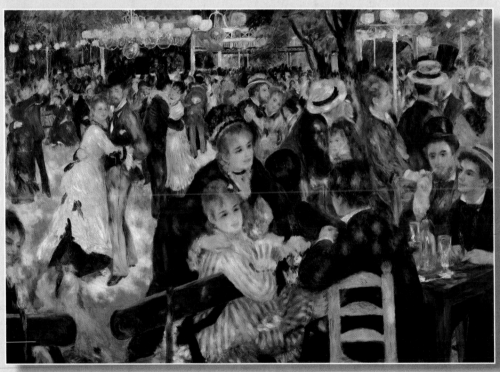

piness, expressed in the pure colours and light palette of the Impressionists. As in a snapshot, Renoir captures a party at a popular Montmartre locale, in the greatest ever painting *en plein-air*.

CHRONICLING PARIS LIFE

MOULIN DE LA GALETTE
1876

● Musée d'Orsay (oil on canvas, 131 x 175 cm)

● Pierre-Auguste Renoir was born in 1841 in Limoges, to a tailor father and factory worker mother. He was still a young child when his family moved to Paris. He trained as a craftsman, decorating first porcelain, then fans and curtains. In 1862 he had enough money to pay for painting lessons from Charles Gleyre at the École des Beaux-Arts, where he met Monet, Sisley and Bazille. Along with them, he admired the masters of the previous generations, particularly Courbet, Corot and the landscape artists of the Barbizon school. He went with his companions to paint outdoors, *en plein-air*, in Fontainebleau forest. In Paris he frequented the Café Guerbois, where young artists congregatéd around Manet and the writer Zola. Shunning the official *Salon* culture, Renoir, Monet, Sisley, Degas, Pissarro and Bazille founded Impressionism. In 1874 Renoir exhibited seven works at the first Impressionist exhibition, held by photographer Nadar.

● In the early 1870s, the "Moulin de la Galette" was a popular Montmartre locale where people went to open-air evening dances. The dance floor was beneath a large shed, with a plinth for the orchestra, set in a large tree-filled garden, where workers, students and young artists met on weekends.

● In his *Moulin de la Galette*, purchased immediately by Renoir's fellow painter and friend Caillebotte, the artist is studying the quality of light and the dynamic depiction of a scene of modern life, following the orientation and experimentations of his companions. Shown at the third Impressionist exhibition, in Rue Le Pelettier in 1877, the painting was enthusiastically received by Georges Rivière, who wrote in the *L'Impressionniste* review: "This is a page of history, a valuable monument to Paris life."

◆ SELF-PORTRAIT (1876, Cambridge Massachusetts, Fogg Art Museum). Renoir's concise style is characterized by free and distinct brushstrokes. His contribution to Impressionism was to apply the new style of painting to the human figure.

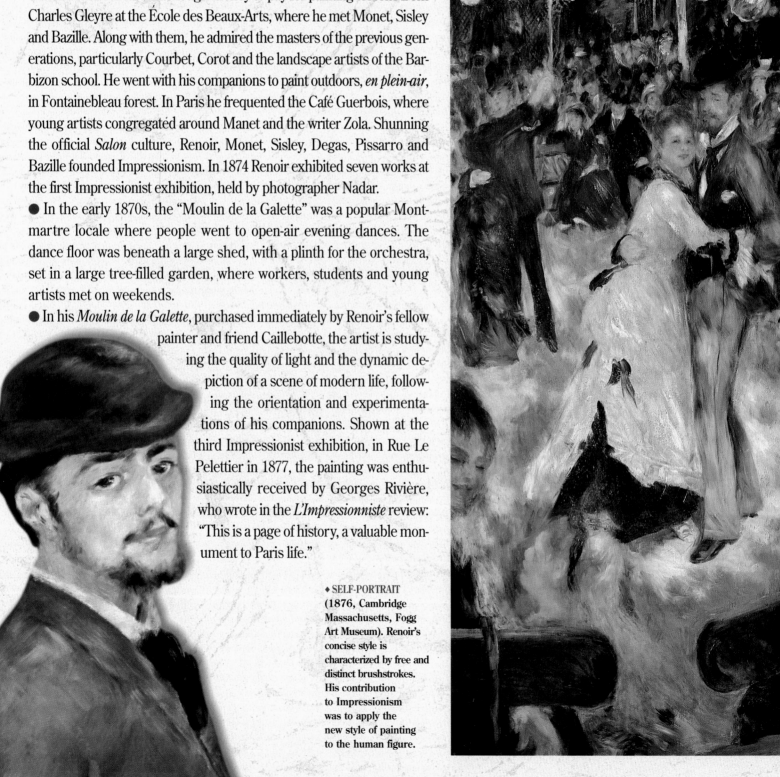

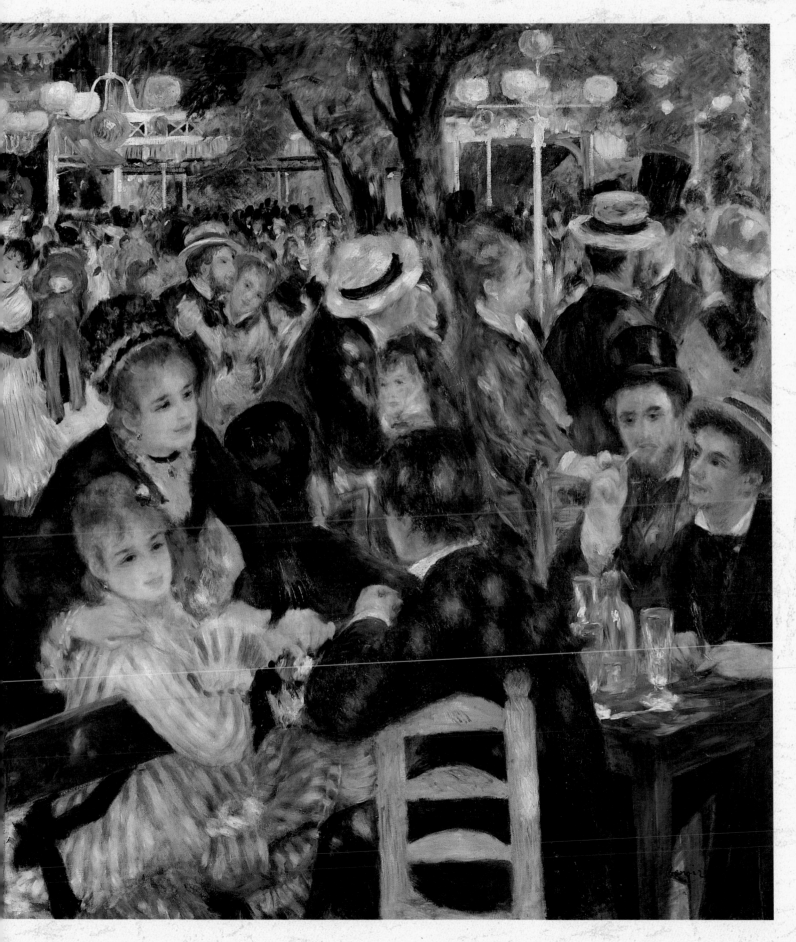

AN ODE TO HAPPINESS

Existential happiness - almost an ode to joy and youth - and a "sketched" quality to the painting, are the first impact of the work. Only a few of the faces in the foreground are handled with the virtuosity of portraiture; in the rest of the painting - and this is one of Renoir's innovations - space is resolved in the inebriating splendour of the colours and light penetrating from above, blending the bodies and the surrounding environment.

● A number of Renoir's friends posed for the work. The women are the young model Estelle, in the striped dress, and her sister, actress Jeanne Samary, who is standing next to her. Sitting around the table are painters and intellectuals, but they are not easily identified with any precision. Among the dancers, behind and to the left, are the couple Marguerite Legrand, known as "Margot", and Pedro Vidal de Solarès y Cardenas, a painter of Spanish origin, wearing a black felt hat.

● "Franc-Lamy, one day, found a preparatory sketch in my atelier for *Moulin de la Galette*. 'You really ought to paint that picture,' he told me. It was very complex: finding the models, a garden… I had the good fortune to receive a well-paid commission: a portrait of a lady and her two daughters, for 1200 francs. I rented a house with a garden in Montmartre for one hundred francs a month… and it was there that I painted *Moulin de la Galette…*"

● In the garden at his Rue Cortot studio Renoir painted not only this famous canvas, but other renowned large format works such as *The Pergola, Nude in Sunlight, The Swing,* and *Claude Monet Painting in his Garden.*

● In order to grasp the lighting and the pose of the characters, the artist painted an initial version of the work on site. Rivière and other friends, who later posed for the painting, helped him to carry the large canvas from his studio to the big outdoor dance hall. In the *plein-air* painting he completely defined both the composition and the colour scheme. Back in his studio he put the finishing touches to the work.

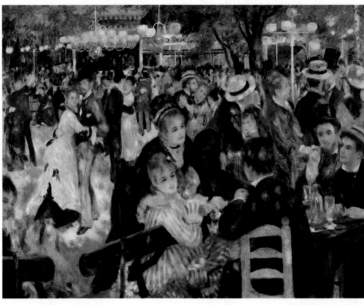

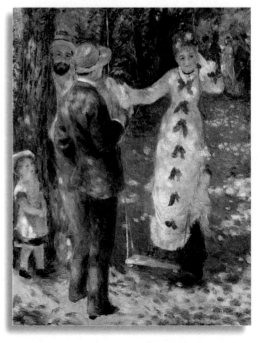

◆ THE SWING (1876, Paris, Musée d'Orsay). Executed in the garden at Rue Cortot, this work contains a number of similarities with *Moulin de la Galette*: its conception of colour, and the singular play of light - filtered through the trees – which creates wide splotches of lighter colour, in the foreground on the man's back, and on the woman's dress. The model, a Montmartre seamstress, is the same Jeanne who is portrayed with her sister in *Moulin de la Galette*. Drawing inspiration from this painting, Zola describes one of his characters as, "Wearing a grey suit set off with mauve knots, one day under a pale sky when the sun was emitting a blond powder." (*Une Page d'Amour*, 1878). Right: A photograph of the Montmartre locale.

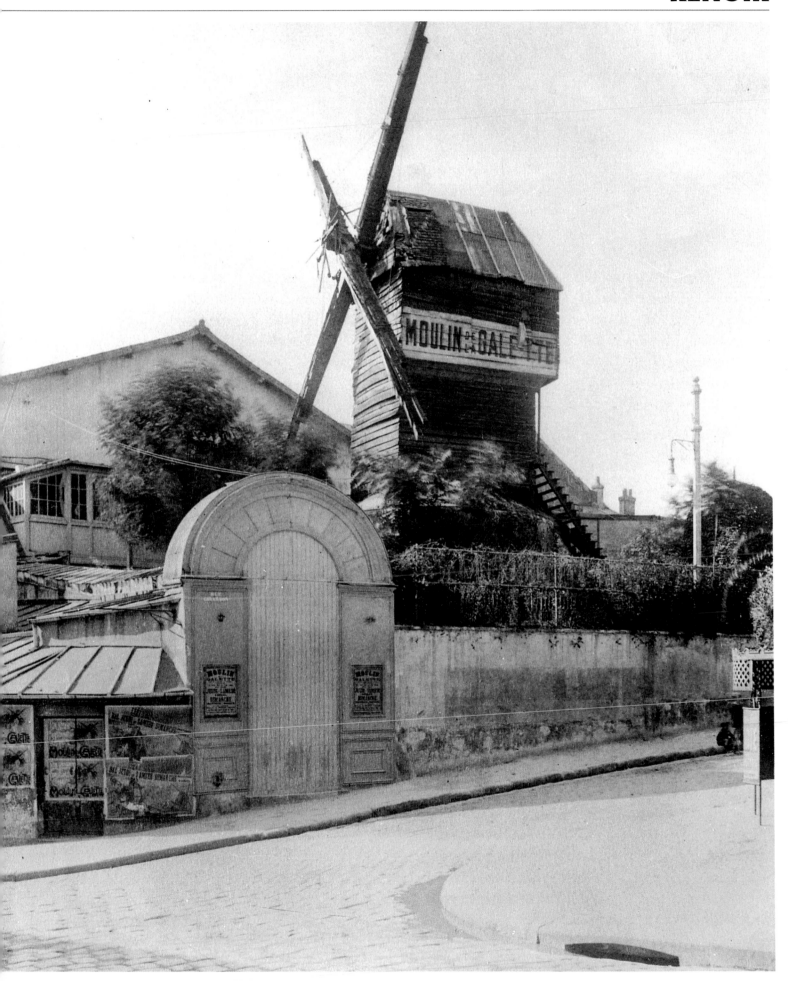

PAINTING MEETS PHOTOGRAPHY

From 1875-6, though still mixing colours on his palette, Renoir began applying pure paint directly onto the canvas, as little luminous dabs which could define a shape by forming a homogeneous tone on the retina of the beholder, standing at a certain distance from the painting. This technique - characteristic of the painting of the early Impressionists, and used as a rule by the painters of the neo-Impressionist movement too - allows the artist, even on large canvases, to render the effects of light as spots of colour which casually fall on bodies, faces and clothing. These spots of light, which are evident on the jacket of the foreground figure whose back is turned to us, are a cypher of Renoir's style in works of this period.

● Elsewhere, particularly in the background of the painting, the light fragments into a myriad of reflecting particles, in a kaleidoscopic effect whose texture borders on that of matter. This fading effect is countered by the blobs of colour. Light and dark chromatic areas alternate in a sinuous rhythmic play which adds depth to the painting and creates an illusion of space.

● Despite the apparent freedom and spontaneity of the scene, captured as in a snapshot, the guiding principles with which the artist constructs and develops his composition bring together the different groups and the various dancing couples. Three diagonals originate in the bottom left-hand corner, diverging to the closer-than-expected backdrop of the painting. It is extraordinary how, in a depiction of such bold articulation, Renoir expresses himself with such felicitousness, and with such a light touch: the space is overcrowded, the foreground is almost completely absent, and his figures are framed in a fashion which recalls the practice of photography. Moreover, the scene is constrained within a limited space by the lack of sky and the absence of a perspective effect, deadening the space beyond the backdrop. Despite all this, the picture irresistibly conveys an air of festivity.

◆ NUDE IN SUNLIGHT (1875, Paris, Musée d'Orsay). His rapid technique allowed Renoir to capture fleeting effects and, using broad and summary brushstrokes, capture the *allure* of the figure. The painter breaks up the polished pictorial surface of traditional paintings with a layout which he himself defined as "risqué". Like other works of this period, this outdoor nude is bathed in the same light – created with splotches of colour – as is part of the setting. Above: Renoir's palette, dominated by light colours.

● To fully understand the character of the painting, one must consider the contemporaneous development of photography. Many nineteenth-century painters were deeply conditioned in their choice of subject by this young art; *Moulin de la Galette*, however, takes this process a step further. Renoir is attempting to go beyond the static nature of poses by experimenting with modulations of light and movement. It is perhaps no coincidence that his son Jean became an accomplished film director.

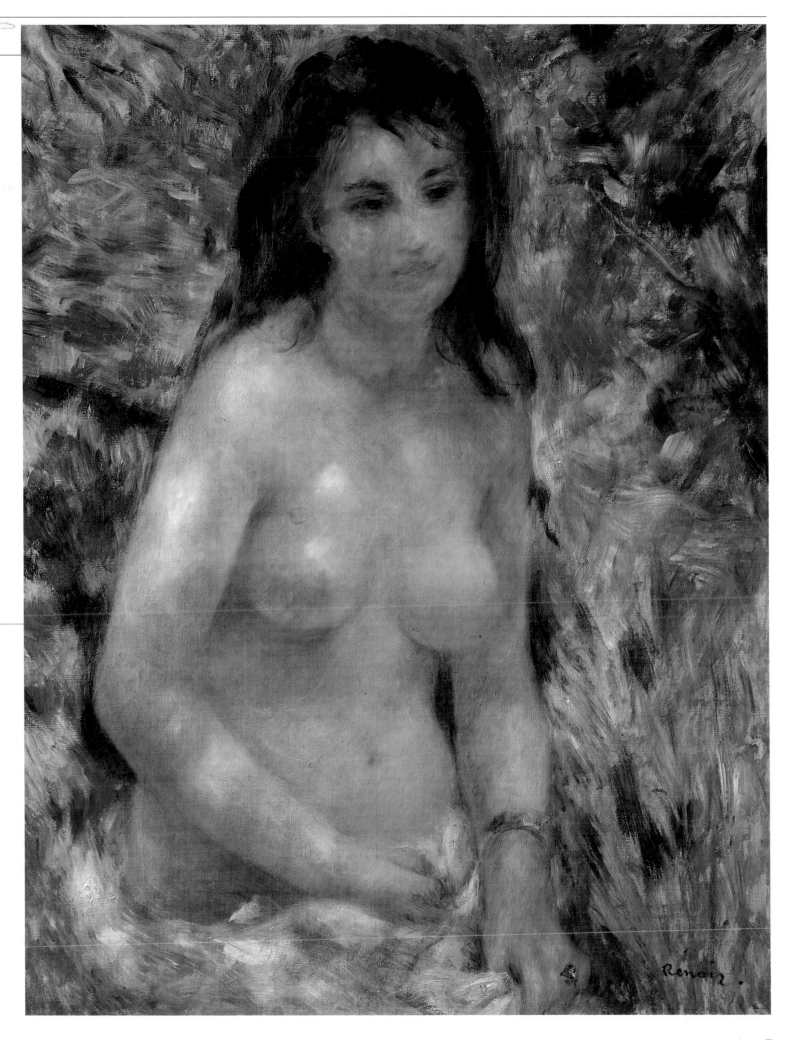

ANALYSIS OF THE WORK: THE SUBJECT
THE THEME OF CONVIVIAL DANCES

Since at least as early as the dancing ladies in the Etruscan mural paintings in Tarquinia, dance has always fascinated artists: woman in costumes who seem posed in mid dance-step in the Roman mosaics of Piazza Armerina; Bruegel, with his peasant dances, where more than anything one is struck by his search for characteristic types; right through to the oneiric country feasts of Watteau, with his predilection for the delicate colours of the time, and for constructing serene atmospheres. Something of all this is to be found in Renoir's painting, but the real strength of the work lies in the way he frees visual perception from all pre-ordained patterns or rules. This revolution in painting took place as his friends Monet, Sisley and Degas, each in his own way, were doing similar things. Without applying common rules, without a specific program, the Impressionists were burning the bridges to the past.

● Renoir is intent on capturing the effects of light on the whirling crowd, and renders the idea of a festive atmosphere through the brilliancy of his colours. He describes the foreground with a certain wealth of detail (in the faces and the

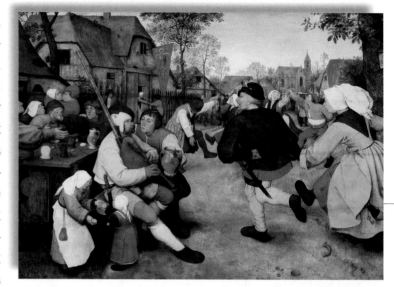

splendid still life on the table), he paints the figures with brushstrokes which are even more fluid than those of Velázquez (look at the striped dress of the woman in the centre), and in the background completely melds forms into the atmosphere and light.

● The light source in the painting comes from two points: one is natural, sunlight, falling from above like gilded rain; the other is artificial, silvery and uniformly diffuse.

● The artistic experiences of tradition are a stimulus to Renoir: he does not enter into competition or a relationship of academic copying, but rather develops a genuine contact, which constitutes a knowing impetus towards innovation. He makes use of the conquests of paintings before his time to enlarge his field of perception. Through intuition - Renoir is not enamoured of theories - his artistic vision indicates the idea of painting free of any representational conclusion. The sole purpose of art is to express itself and its means; to bring to life impressions and their effects as awareness of the subject, without apparent pre-meditation..

● The extraordinary innovation of this work was spotted by Georges Rivière, Renoir's friend and biographer: "Nobody before Renoir had thought of capturing a moment of everyday life on such a large canvas; his is a bold move which success shall reward as is fitting." (*L'Impressionniste*, 1877).

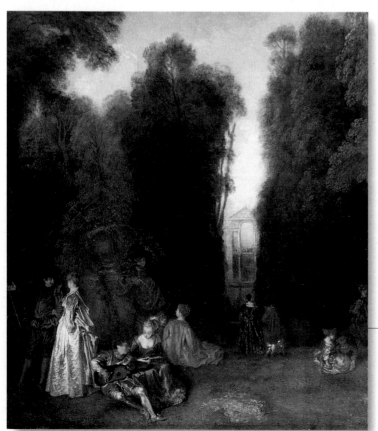

◆ JEAN-ANTOINE WATTEAU
Refined Rendezvous at a Pond (1715, Boston, Museum of Fine Arts, detail). Watteau's favoured theme of the *Fête galante*, his idea of the landscape, colour and light fascinate Renoir, who draws inspiration from him for his felicitous and serene ambiences, and for the brilliancy of his hues, applied with changing and precious effects.

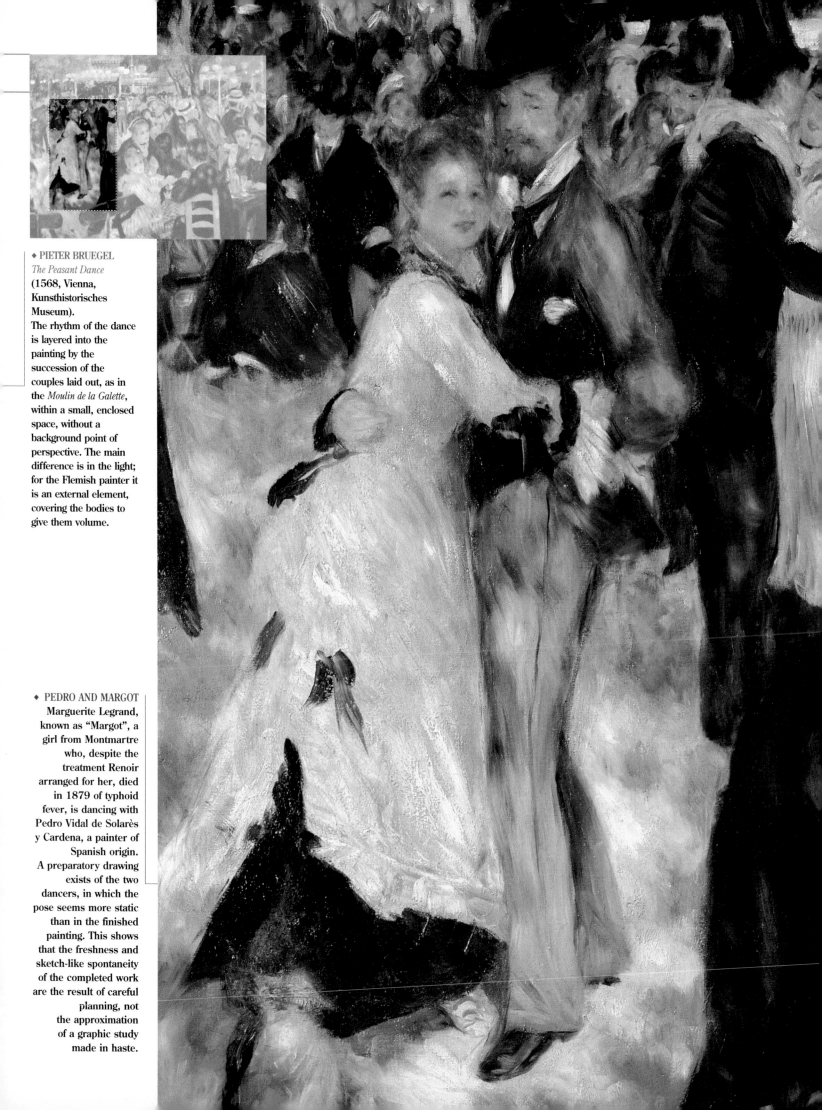

◆ PIETER BRUEGEL
The Peasant Dance
(1568, Vienna,
Kunsthistorisches
Museum).
The rhythm of the dance
is layered into the
painting by the
succession of the
couples laid out, as in
the *Moulin de la Galette*,
within a small, enclosed
space, without a
background point of
perspective. The main
difference is in the light;
for the Flemish painter it
is an external element,
covering the bodies to
give them volume.

◆ PEDRO AND MARGOT
Marguerite Legrand,
known as "Margot", a
girl from Montmartre
who, despite the
treatment Renoir
arranged for her, died
in 1879 of typhoid
fever, is dancing with
Pedro Vidal de Solarès
y Cardena, a painter of
Spanish origin.
A preparatory drawing
exists of the two
dancers, in which the
pose seems more static
than in the finished
painting. This shows
that the freshness and
sketch-like spontaneity
of the completed work
are the result of careful
planning, not
the approximation
of a graphic study
made in haste.

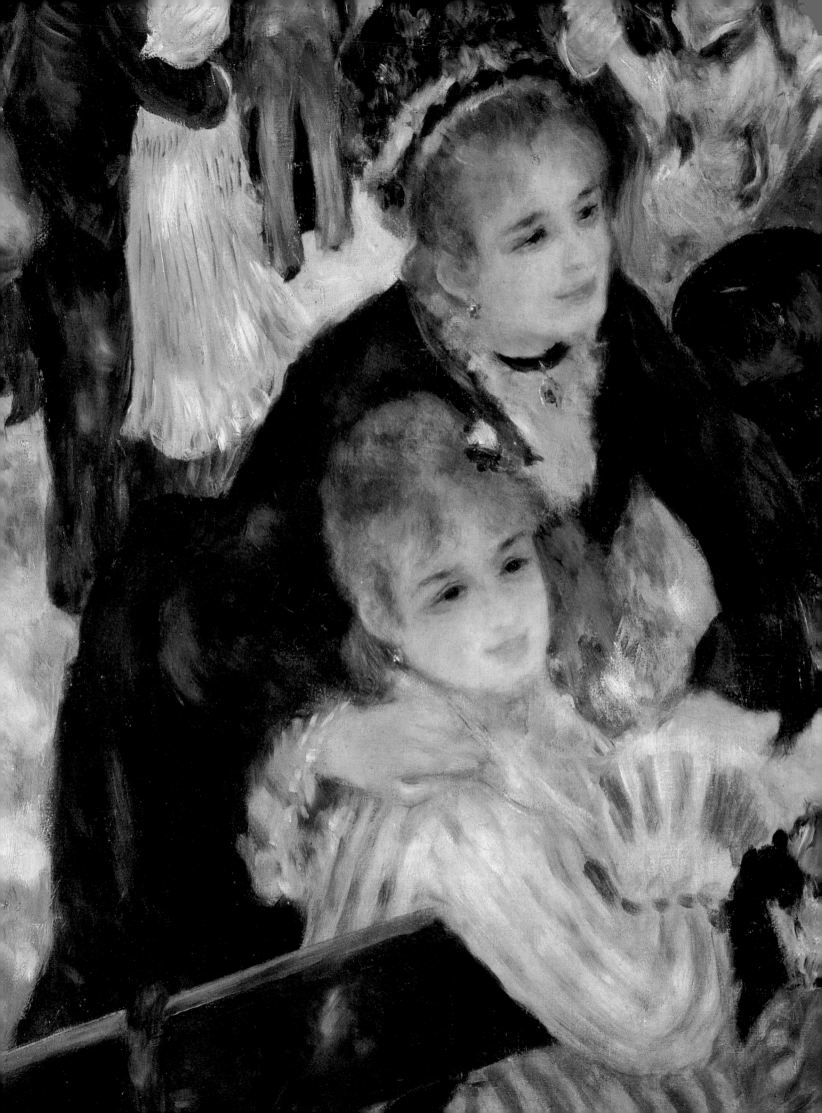

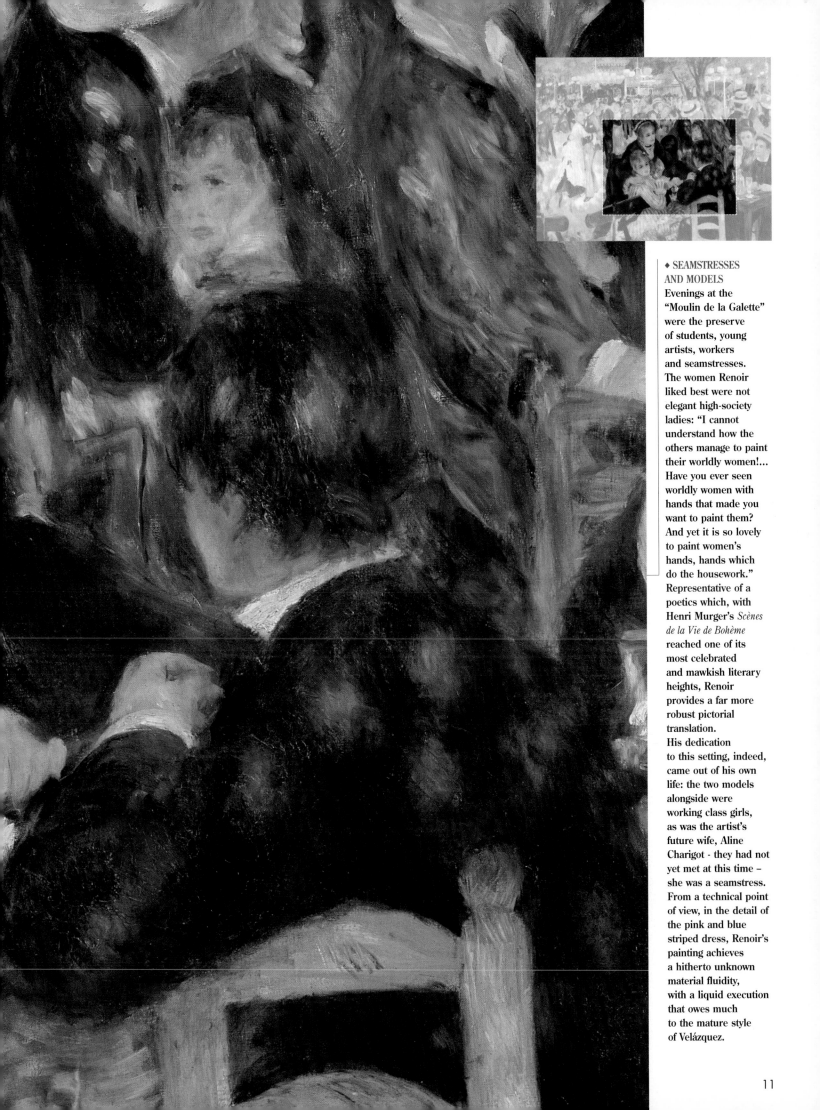

♦ SEAMSTRESSES
AND MODELS
Evenings at the
"Moulin de la Galette"
were the preserve
of students, young
artists, workers
and seamstresses.
The women Renoir
liked best were not
elegant high-society
ladies: "I cannot
understand how the
others manage to paint
their worldly women!...
Have you ever seen
worldly women with
hands that made you
want to paint them?
And yet it is so lovely
to paint women's
hands, hands which
do the housework."
Representative of a
poetics which, with
Henri Murger's *Scènes
de la Vie de Bohème*
reached one of its
most celebrated
and mawkish literary
heights, Renoir
provides a far more
robust pictorial
translation.
His dedication
to this setting, indeed,
came out of his own
life: the two models
alongside were
working class girls,
as was the artist's
future wife, Aline
Charigot - they had not
yet met at this time –
she was a seamstress.
From a technical point
of view, in the detail of
the pink and blue
striped dress, Renoir's
painting achieves
a hitherto unknown
material fluidity,
with a liquid execution
that owes much
to the mature style
of Velázquez.

11

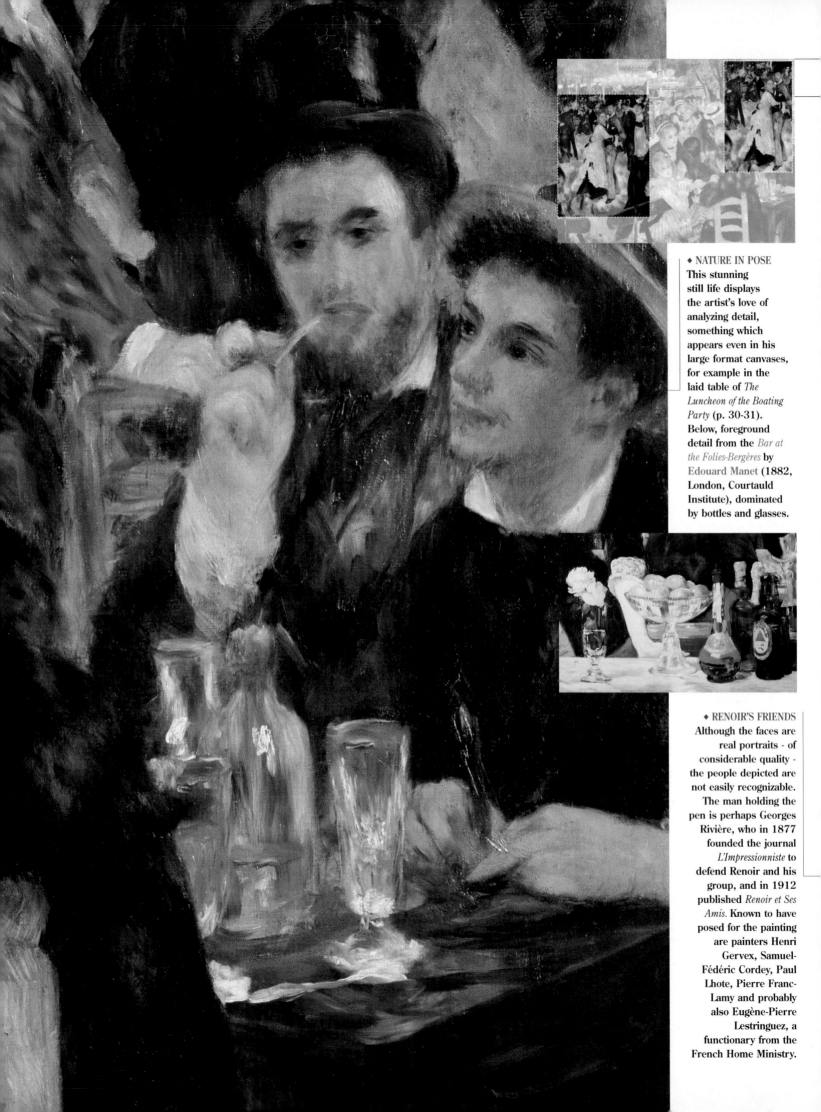

♦ NATURE IN POSE
This stunning
still life displays
the artist's love of
analyzing detail,
something which
appears even in his
large format canvases,
for example in the
laid table of *The
Luncheon of the Boating
Party* (p. 30-31).
Below, foreground
detail from the *Bar at
the Folies-Bergères* by
Edouard Manet (1882,
London, Courtauld
Institute), dominated
by bottles and glasses.

♦ RENOIR'S FRIENDS
Although the faces are
real portraits - of
considerable quality -
the people depicted are
not easily recognizable.
The man holding the
pen is perhaps Georges
Rivière, who in 1877
founded the journal
L'Impressionniste to
defend Renoir and his
group, and in 1912
published *Renoir et Ses
Amis*. Known to have
posed for the painting
are painters Henri
Gervex, Samuel-
Fédéric Cordey, Paul
Lhote, Pierre Franc-
Lamy and probably
also Eugène-Pierre
Lestringuez, a
functionary from the
French Home Ministry.

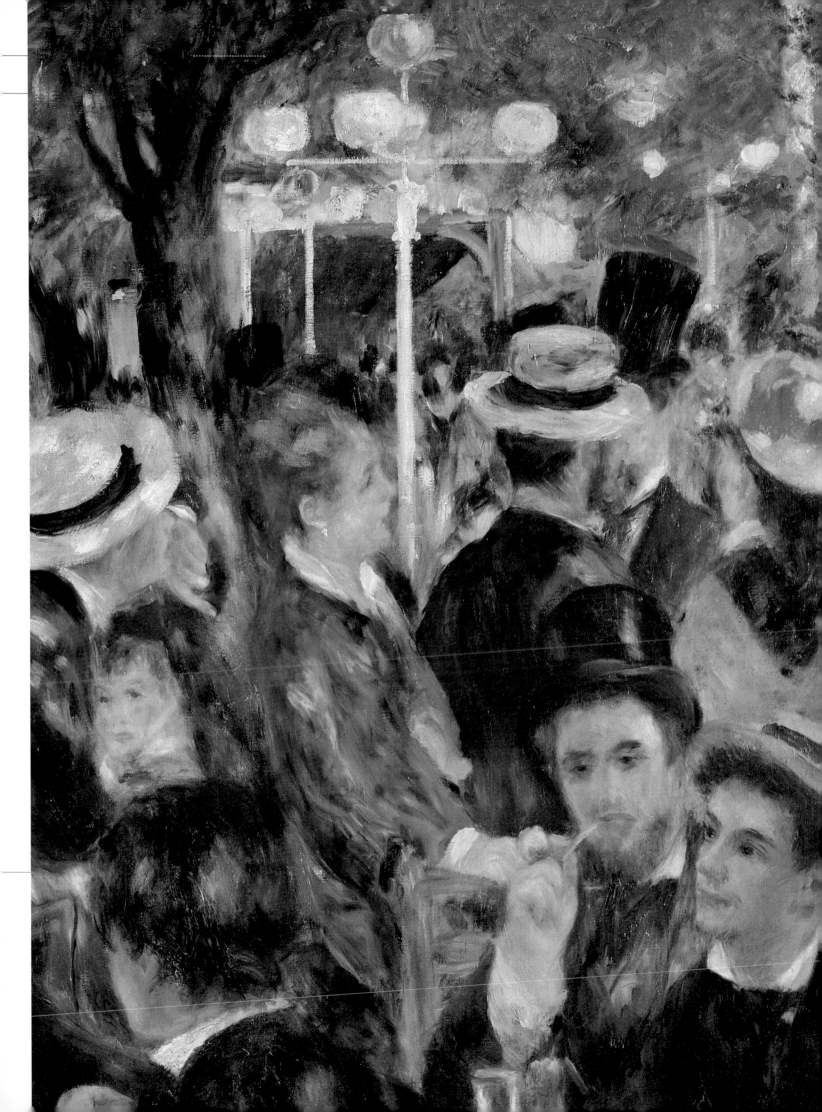

PAINTING AS A TRADE

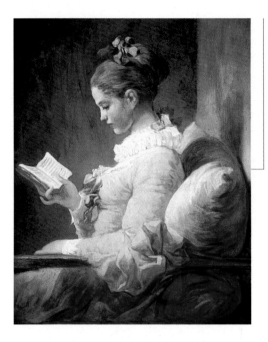

◆ JEAN-HONORÉ FRAGONARD *The Reader* (ca. 1776, Washington National Gallery). The theme of a figure caught up in the act of reading is very dear to the heart of both Fragonard and Renoir. However, though the earlier artist resolves the composition in an act of virtuosity, working with warm hues of yellow, Renoir studies the light as an element which can modify the very structure of the real image, and be used to compose a better pictorial image.

"As one theory, doctrine, aesthetic, metaphysics and physiology of art followed another, Renoir's work developed year by year, month by month, day by day, with the simplicity of a flower blooming, a fruit ripening. Renoir did not think of fulfilling his own destiny: he lived and painted. He conducted his trade. And that, perhaps, is where his genius lies." Mirbeau's comment at the 1913 Renoir retrospective held at the Bernheim Gallery in Paris reveals an important aspect of the artist's character: for Renoir, painting was, first and foremost, a matter of dedication and hard work. This conviction, which perhaps derived from his apprenticeship as a craftsman, was very similar to the outlook espoused in England at that time by critic John Ruskin (1819-1900), William Morris's (1834-1896) *Arts and Crafts* movement, and the painters of the pre-Raphaelite brotherhood (founded in 1848).

● Renoir began his training in a porcelain factory. "My task," the artist told art dealer Ambroise Vollard, "was to paint little *bouquets* on white backgrounds, for which I was paid 5 sous a dozen… When I grew more confident, I moved on from the bouquets to figures, for the same miserable wage." This was where Renoir learned to paint with soft, thin, rounded brushes, using fluid and very taut paints, required to seep into the painting medium. The artist continued with this technique more or less throughout the rest of his life.

● Between 1854 and 1858, while working in the factory, and as late as 1860, Renoir spent his free time at the Louvre, where he was attracted by the sculptures, and discovered the *Fountain of the Innocents* by French sculptor Jean Goujon (ca. 1510 - ca. 1566). These works guided the painter in the plasticity of his nudes. At the Louvre he made copies from Fragonard, Boucher and Watteau, from whom he inherited a love of light, vaporous colours, and a certain compositional freedom in his bucolic scenes.

● When the porcelain-painting factory underwent a slump because of the mechanization of the methods of production, Renoir found himself out of a job. He found employment with a painter of curtains and hangings, and began painting sacred subjects on canvas for missionaries. Then, he enrolled at the Académie des Beaux-Arts; at the studio of Charles Gleyer he met Monet, Sisley and Bazille, with whom, from 1863, he embarked on the experience of painting *en plein-air*.

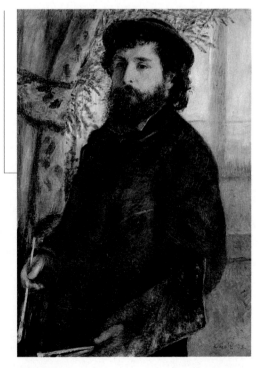

◆ CLAUDE MONET WITH PALETTE (1875, Paris, Musée d'Orsay). Monet is considered the main driving force of the Impressionists. This painting, for which two preparatory studies exist, belongs to Renoir's Impressionist period; in the same year he painted an outdoor portrait of his friend, as Monet was painting in the garden at Rue Cortot. In the oval above: *Study for a decorated vase*, executed by the teenaged painter during his spell working at the porcelain factory (ca. 1858, Viroflay, private collection).

◆ WOMAN READING (1875-6, Paris, Musée d'Orsay). Renoir was slower to apply the Impressionist technique to his portraits and nudes, perhaps because his ideal of beauty did not lend itself to an accentuated fragmentation of spots of colour. In any event, his most original innovation is in painting the human figure subjected to the dynamic intensity of the rhythm of light, as in the face of this woman, which is moulded by the gilded luminosity of the light.

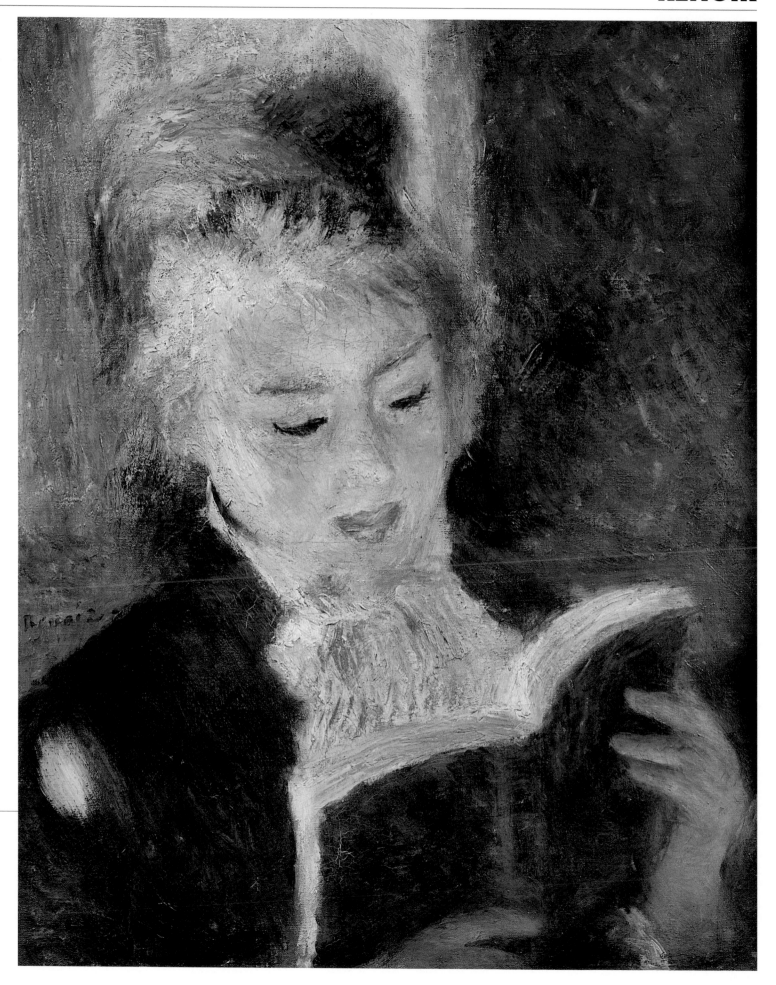

BEGINNINGS

M ore significant to Renoir's training than the teachings of his tutor Gleyer, an academic painter who studied under David, was the painting of Courbet, Corot and Manet.
● The painter spent much of the spring of 1865 in Fontainebleau forest, with Sisley, Pissarro and Monet. His works from this period are infused with Courbet's realism of subject and atmosphere. A work such as *The Inn of Mother Anthony*, painted in 1866, in which the subject is clearly inspired by Courbet's *Inn at Ornans*, is a manifesto of adhesion to Zola's theory of naturalist art.
● Renoir often went painting with Monet. Both of them paint-

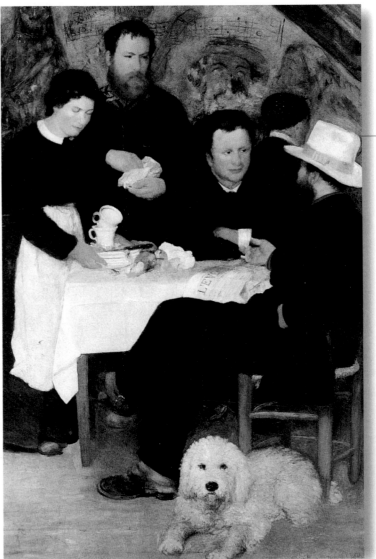

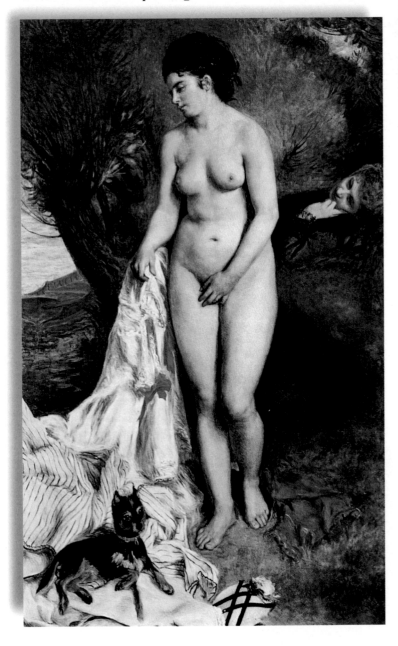

ed the *Grenouillère*, a restaurant/bathing resort on the island of Croissy, in the Seine, opposite Bougival. Renoir executed a number of paintings of the spot, a favourite with Parisians at leisure, in the summer of 1869: these were his first Impressionist works. In 1873, at Argenteuil, the two friends once again set to work on a common subject.
● The motifs of Impressions are evident in the *plein-air* landscapes and subjects, which are bursting with light and sparkling colours. And yet, in his portraits and indoor scenes, Renoir's forms remain more plastic, the colours deeper. Renoir's Impressionist period, after his first, timid approaches in the *Grenouillère* canvases, ran from 1872 to 1881: during these years he used light not just to construct landscapes, but also to build the human figure. If Monet purifies the Impressionist style, transforming the vibrations of light into style, and no longer an annotation of the real, Renoir has the merit of extending the new style to the representation of the human body and compositions with figures.

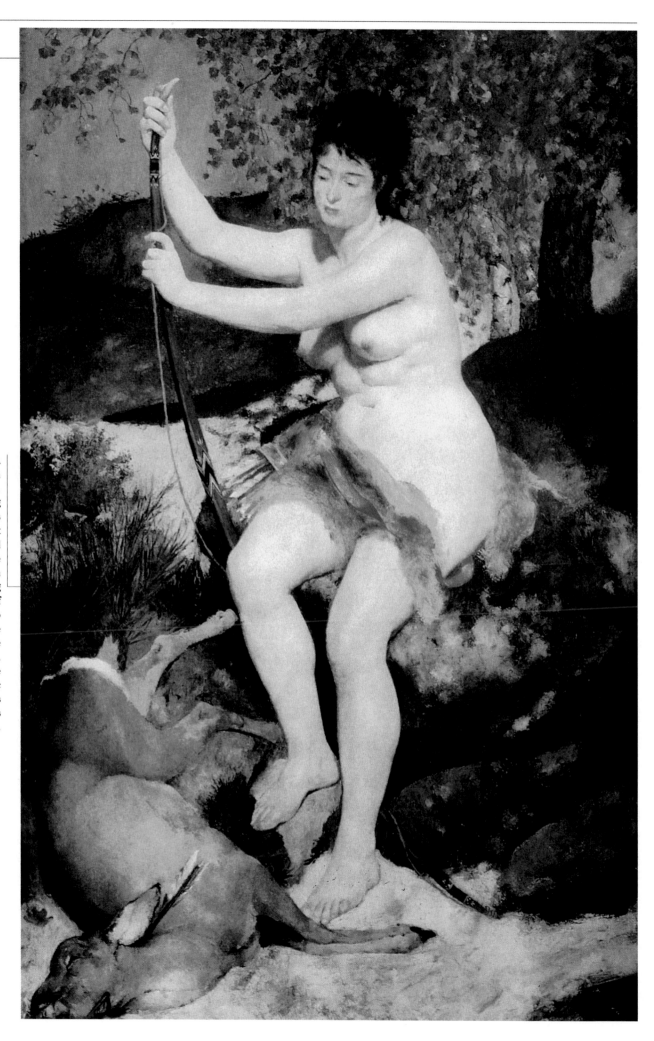

◆ THE INN
OF MOTHER ANTHONY
(1866, Stockholm,
Nationalmusuem).
The inn in question is
at Marlotte, near
Fontainebleau, where
Renoir was staying.
In the painting are the
inn-keeper, her back
turned, her daughter,
Monet (or Renoir)
and Sisley, with
the newspaper
L'Evénement, for which
Zola edited the
literature page.
Jules Le Coeur is
standing. The painting
is an explicit adhesion
of Renoir and
his companions
to the socialist ideology,
as professed by
Courbet and Zola.

◆ DIANA
(1867, Washington
National Gallery).
Renoir tells of painting
a nude (the model is
Lise Tréhot) without
any mythological
reference
in mind, and then
subsequently adding
the accoutrements of
Diana the huntress to
please the taste of the
academic jury of the
1867 *Salon* - which,
however, rejected the
work. In its realistic
style, the canvas
strongly shows
Courbet's influence.

◆ BATHER
WITH A GRIFFON
(1870, San Paolo,
Museu de Arte).
This work also
shows a strong
Courbettian influence
in its composition
and style, a far
cry from Renoir's
contemporaneous
experimentation,
together with
Monet, with light
and colour, for
example in the
Grenouillère.

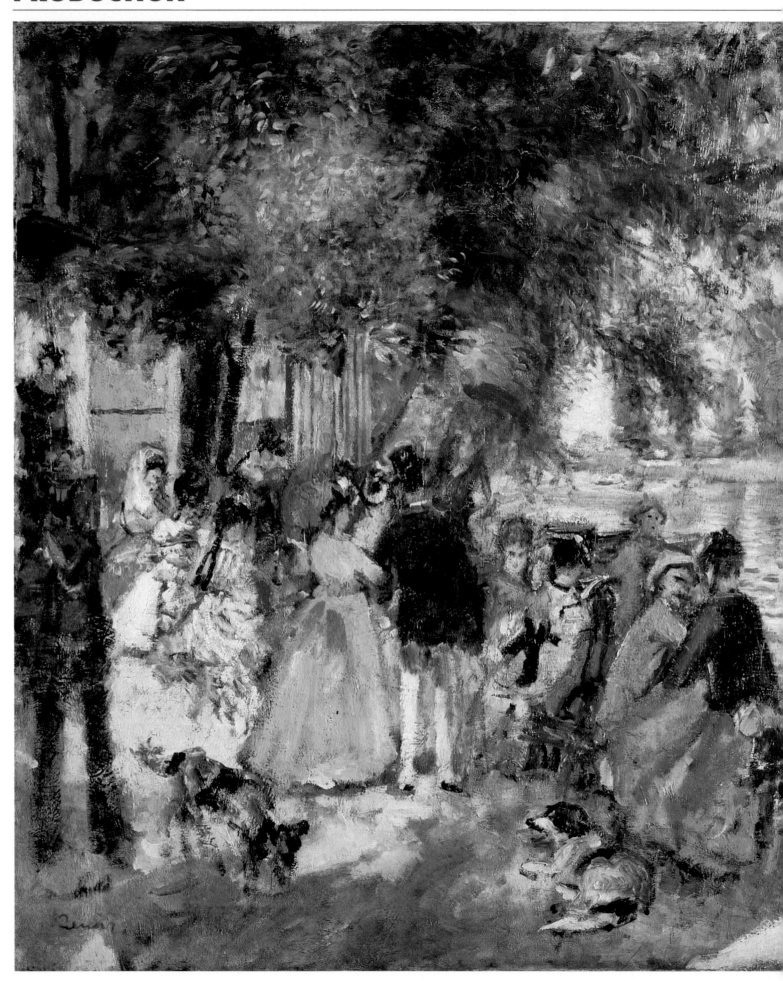

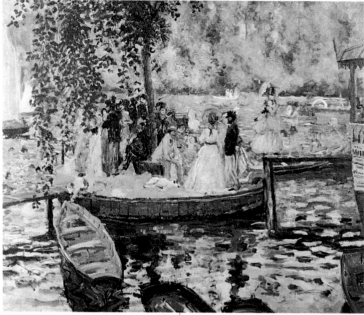

♦ GRENOUILLÈRE (1869, Stockholm, Nationalmuseum). In these early works one may note that the fragmentation of spots of colour is used principally to render the reflections of light on the water, while the figures and landscape remain extraneous to the process. The canvases of this period therefore display a dichotomy: the houses, trees and figures continue to be represented in the traditional realistic manner. In the *Path Climbing Through Long Grass* (1874, Paris, Musée d'Orsay, below) it may be noted how the diffraction of colour, which accentuates the vibrations of the light, encompasses both the setting and the figures.

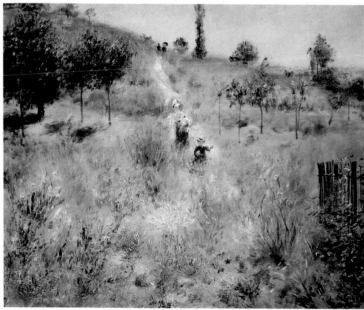

♦ GRENOUILLÈRE (1869, Moscow, Pushkin Museum). Lionello Venturi explains how Impressionism came into being "in a legendary though correct fashion. In the years leading up to 1870 three young men, Monet, Renoir and Pissarro, fell into the habit of going to sit on the banks of the Seine and the Oise to paint landscapes. They were realist painters, who were highly interested in rendering the reflections of light on the water... The colours they discovered in the reflections suggested to them the idea of expressing light through the contrast of colours, without using dark tones for shadows. In this manner... they put lighter paints onto their palettes and broke up the colours." In this canvas one may perceive the passage from realism to the new style of painting.

PRODUCTION

THE NADAR EXHIBITION AND THE POOR RECEPTION OF THE IMPRESSIONISTS

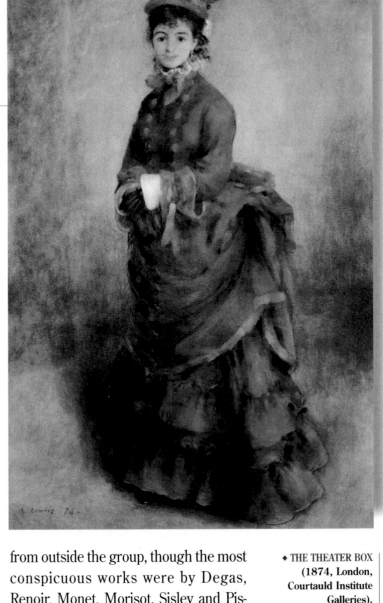

◆ LA PARISIENNE (1874, Cardiff, National Museum of Wales). The work arouses a sensation of simplicity and naturalness, achieved above all through an effortless style, with obvious fading, a purity of tone and masterly colour combinations. Below: Gaspard-Félix Tournachon, known as 'Nadar' (1820-1910).

The first Impressionist exhibition was held between 15 April and 15 March 1874, at Nadar's photographic studio on Boulevard des Capucines in Paris.

● "The public flocked to the event, but evidently they were biased, and instead of recognizing these great artists, they saw presumptuous and ignorant men who wanted to make a name for themselves by being eccentric. The result was a groundswell of public opinion against them." Thus wrote art dealer Durand-Ruel in his memoirs. Despite the poor reception, Renoir succeeded in selling *The Theatre Box*, one of the seven works he exhibited. The canvases on display, including the hedonistic *Dancer*, *La Parisienne* and *The Theatre Box*, contain references to French masters of the eighteenth century, such as Fragonard and Boucher, particularly in the use of faint and soft colours, with which Renoir achieves effects of transparency and fading.

● In 1875, with Sisley, Berthe Morisot and Monet, the painter arranged an auction of the works which were unsold by Nadar, at the Hotel Drouot. This venture was a total failure. The second Impressionist exhibition, still simply billed as an *Exposition de peinture*, arranged in 1876 in Durand-Ruel's gallery in Rue Le Pelettier, was not as much of a failure as the first, but it was hardly much of a step forward for the movement. Also on show were artists from outside the group, though the most conspicuous works were by Degas, Renoir, Monet, Morisot, Sisley and Pissarro. Manet and Cézanne were not part of the show. In 1877, at the same gallery, a third show was held, at which Cézanne also exhibited. Historically, this was the most significant, as for the first time it was openly billed as the *Exposition des Impressionnistes*. To mark the occasion, a limited run of Georges Rivière's journal *L'Impressionniste* was published.

◆ THE THEATER BOX (1874, London, Courtauld Institute Galleries). The only work Renoir sold - for 425 francs - at Nadar's exhibition. The triangular composition, photographic style and Impressionistic brushstrokes achieve an intense clarity of colour scheme, based on the contrast of black and white.

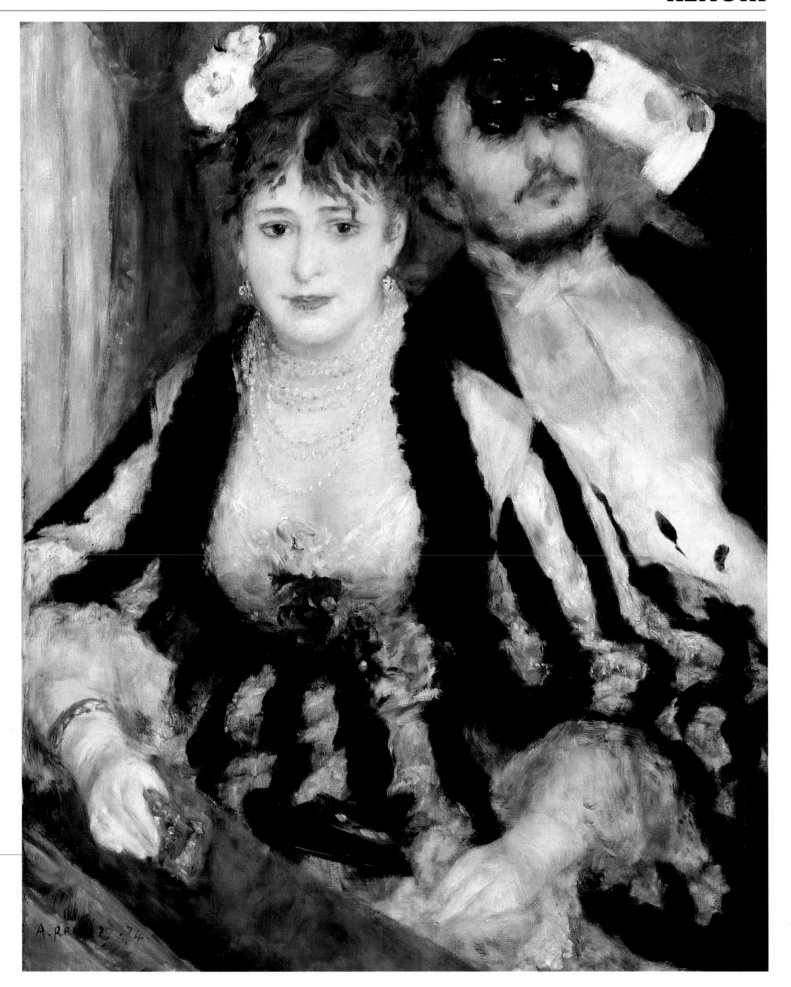

PRODUCTION

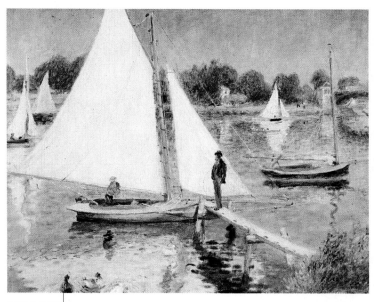

♦ SAILS ON THE SEINE
AT ARGENTEUIL
(1873, Portland
Museum of Art).
Argenteuil, a town on the
Seine river in northern
France, was one of the
Impressionists' favourite
spots. In the summer
of 1873, Monet and
Renoir went there
together to paint. While
Monet - in canvases such
as *Sailboats at Argenteuil*
(1872, Paris, Musée
d'Orsay) - attempts
to resolve space on the
plane with the insistent
whites of the sails,
Renoir renders the space
by alternating the whites
with areas of shade,
painted with a changing
combination of colours.

♦ OARSMEN AT CHATOU
(1879, Washington,
National Gallery of Art).
Alongside the self-
portrait of the painter in
a light jacket, for the first
time we see Aline
Charigot, the model
whom Renoir was to
marry at a civil
ceremony in 1890. They
later had three children.
The composition
retraces Monet's *Seine at
Argenteuil* (1874), but
the style is different,
with a fragmentation
of colour into dabs now
extended to the whole
picture, along with
Renoir's 'risqué' painting
area, the way he renders
the light, and an
'unfinished' style.

♦ GARDEN
(1875, Venturi
Archive).
Immersed
in sunlight, nature
is almost pulverized.
Even the figures
become an integral
part of the
setting, while
the scheme
of the painting
retains its unity.
Spatula strokes
alternate with almost
liquid brushstrokes,
which allow the canvas
to show through.
In a constant flux
of matter and
chromatic impastos,
Renoir serves the
viewer a slice of
enchanted nature.

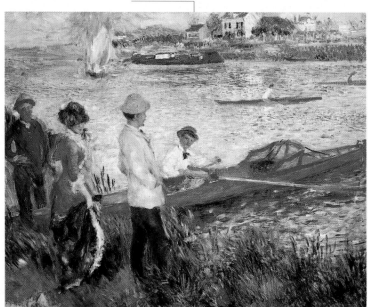

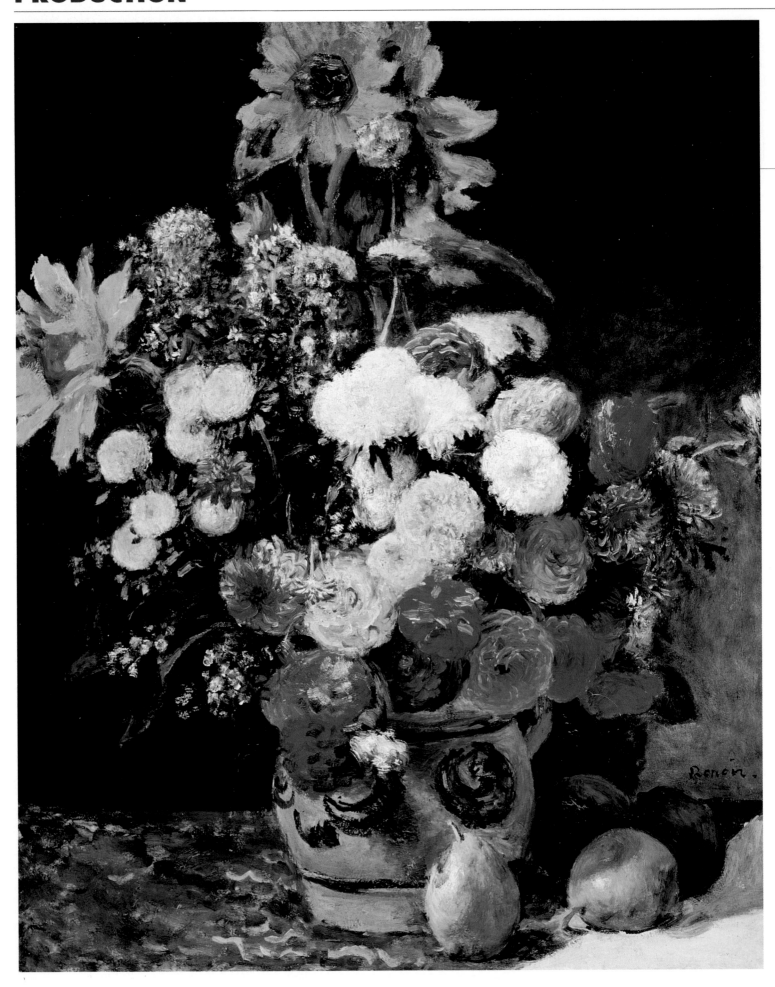

◆ FLOWERS IN A VASE (1869, Boston Museum of Fine Art). During this period, Renoir painted outdoors with Monet: the same vase appears, in effect, in one of his friend's paintings. The artist's attentiveness to chromatic values is no less with these flowers than with his other subjects. One day the artist confided to his friend Vollard that the variation of colours he used for the flowers was in fact a study of flesh tones to be used for nudes.

◆ DANCER (1874, Washington, National Gallery). This painting, exhibited at the first exhibition of Impressionists alongside works such as *The Theatre Box* and *La Parisienne* - with which it shares similarities of chromatic experimentation - is based on a setting created with light transitions of tone, a technique whose roots lie in eighteenth-century French painting. At Nadar's exhibition, the painting was criticized by Joseph Vincent, who, according to Louis Leroy's report said, "What a shame... that the painter, with his awareness of colour, does not paint better: the legs of his dancers, are as limp as the veil of the tutu." In reality, Renoir has consciously renounced definition of the figure through drawing, choosing not to insert the figure into a spatial frame of reference: he leaves her free, floating in an undefined space. During these same years, with more pointed psychological research, Degas envelops his own dancers in a timorous form, within a studied construction.

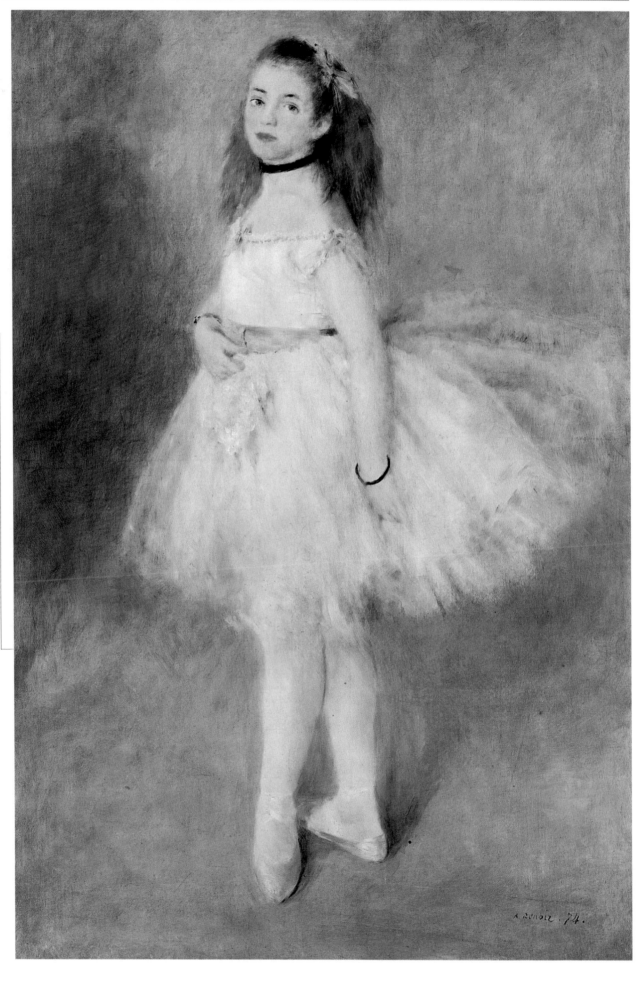

PRODUCTION

AROUND MANET THE "CAFÉ GUERBOIS"

1867 saw the rejection of Renoir's works by the *Salon* - including his *Diana*. Fortunately Sisley, and then Bazille, both of whom came from affluent families, helped Renoir out during these hard economic times, sharing their studio with him. In this period the painter frequented first the "Café Guerbois", in the Batignolles quarter, and later the "Nouvelles Athènes" café, a place where young intellectuals and painters gathered around the charismatic figures of Manet and Zola.

● In 1877, in an attempt to win acceptance from academic circles, Renoir fell in with the culturally more conformist high society, spending time, for example, at the home of the publisher Mr. Charpentier, one of the highest profile personalities in Paris. His portraits of these people (*Madame Charpentier*, and

Madame Charpentier and Her Children) opened the doors to success, and an invitation to join the *Salon* in 1879. In 1880, he painted the portraits of the daughters of banker Chaen d'Anvers and of diplomat Paul Bérard.

● On 4 March 1881, accompanied by his friend Cordey, Renoir went to Algeria, where he was joined by painters Lestringuez and Lhote. During his month there, he painted a number of landscapes. That October he travelled to Italy, journeying to Venice, Florence, Rome, Naples, Capri and Palermo. On this trip he visited the landscapes which had inspired Delacroix, in paintings he had admired a decade earlier in Paris. While travelling, the painter continued his study of colour and his search for the pictorial values of light, rendered with increasingly thick and vibrant brushstrokes.

◆ MADAME CHARPENTIER AND HER CHILDREN (1878, New York, Metropolitan Museum). The wife of the publisher of Zola, Flaubert and Maupassant, lived in Paris in the Rue de Grenelles. Here she is painted with her daughters and pet dog, in her Japanese-style drawing room, which was frequented by artists, intellectuals and politicians. In an excerpt from *Temps Retrouvé*, in which he eulogizes the picture, Proust describes her as a "ridiculous petit-bourgeois woman."

◆ ODALISQUE (1870, Washington, National Gallery of Art).
This exotic subject, though painted in the studio, enables Renoir to explore the full expressive potential of colour.
At the 1870 *Salon*, critic Houssaye described the canvas as "an Algerian woman to whom Delacroix would put his signature," alighting on one of the reference models for the scene. The other is Ingres. The Franco-Prussian war, and the Comune, coincided with a period of crisis in Renoir's output, which he overcame through lessons drawn from the two French masters, conveyed with his modern colour

26

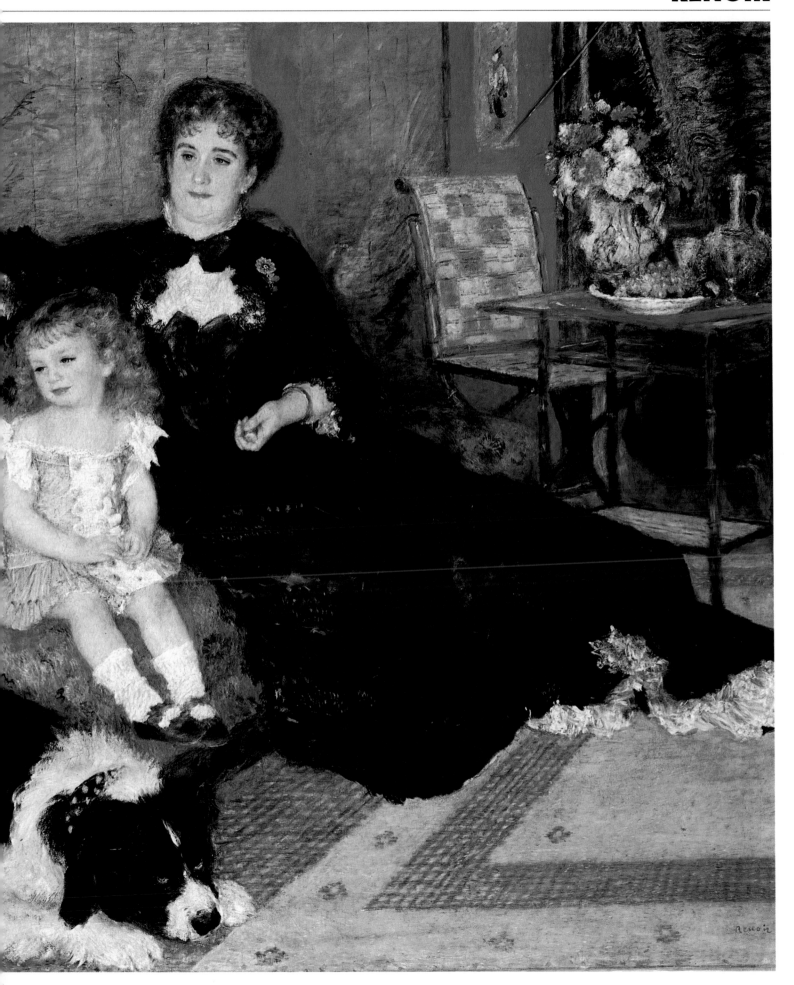

THE "AIGRE" PERIOD

"Around 1883, there came a watershed in my art," Renoir told art critic Vollard. "I had gone as far as I could with Impressionism, and I felt that I didn't know how to paint or to draw; in a word, I was in a cul-de-sac." This marked the beginning of the period which Renoir himself defined as *aigre* (sour or harsh), named for the dry, acidic colours characteristic of his palette. This marked the end of his Impressionist period.

● The change is evident in the three panels *Dance at Bougival*, *Dance in the Country* and *Dance in the City*, which he began in 1882-3. After placing light at the centre of his Impressionist research, for example in the landscapes he painted at Bougival or Argenteuil, Renoir relegated it to a position of lesser importance. No longer is light an end in itself; it becomes a pictorial tool, subordinate to drawing and composition. The painter softens his palette, using cold, acid colours, at the same time simplifying his drawing until it becomes almost gaunt. The dry lines and tones in his figures, such as the refined linearity of the figures in *The Bathers*, painted in 1885, verge on mannerism.

● Renoir's interest in the human form, particularly in women, his admiration for classical painters, enhanced by his discovery of Raphael and the frescoes at Pompeii, brought him closer to the painting of Ingres (some critics dubbed his brief *ai-*

gre style period as "Ingresque"). Renoir sought an answer to his artistic doubts in the French master, in Florentine and Flemish painters, and in Raphael. In 1883 he read Cennino Cennini's *Trattato della Pittura*; he was later to write a preface to the 1911 edition of this book. The treatise, written in the late fourteenth century, had been translated into French by one of Ingres's pupils. Renoir's interest in this work was one of the reasons behind his return to the traditional ways; he also drew once more on his craftsman's love of technique, and on the rules of "good painting", an expression which crops up often in his writings.

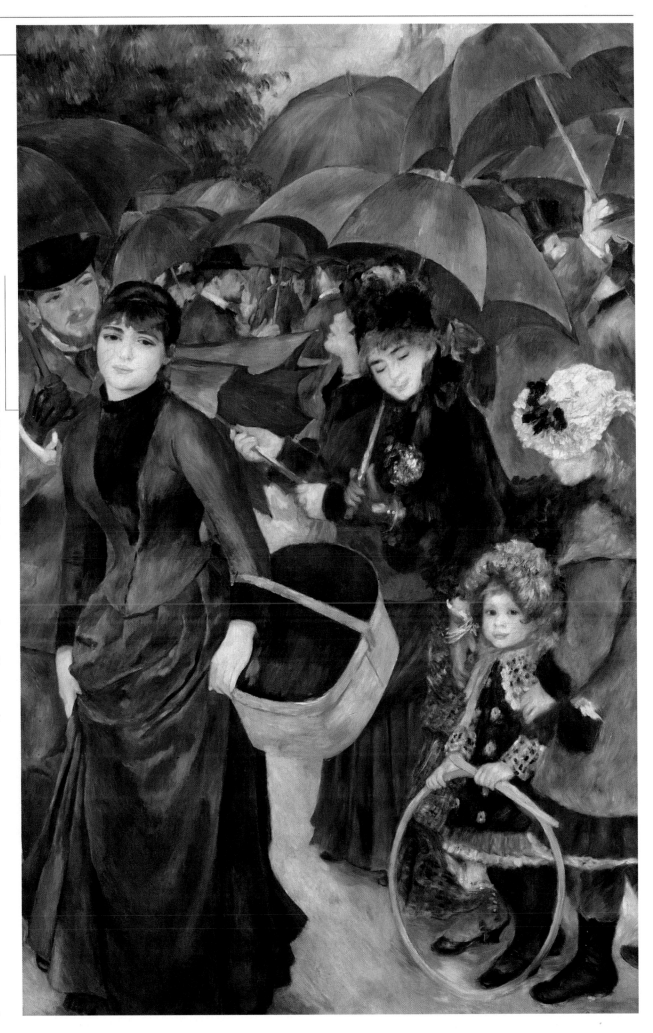

◆ BLOND BATHER
(1881, Turin,
Agnelli Collection).
One of the finest
canvases from his
journey through Italy,
probably painted in
Naples. The triangular
composition
demonstrates his
admiration for and
study of Raphael.

◆ UMBRELLAS
(ca. 1883, London,
National Gallery).
This work belongs to a
transitional period, and
as such it incorporates
both of Renoir's
techniques: in a
general sense, a dry
style of painting based
on drawing, though the
leaves on the trees and
the little girls are
partially depicted with
thick, brushstrokes.
The successive curves
of the umbrellas
provide rhythm and a
feeling of space.

◆ THE BATHERS
(1884-87, Philadelphia,
The Philadelphia
Museum of Art).
The sanguine to the left
is one of several
studies for the work.
During a visit to
Renoir's atelier, painter
Berthe Morisot
remarked to Renoir,
"All these preparatory
studies for a painting
would be of enormous
interest to the public,
who generally believe
that the Impressionists
work at great speed.
These women are as
appealing as Ingres's
women."
In this picture, a fine
specimen of his *aigre*
period, colour is
consistent within the
sharp, well-delineated
contours, while the
Impressionist
technique is confined
to the landscape alone.

PRODUCTION

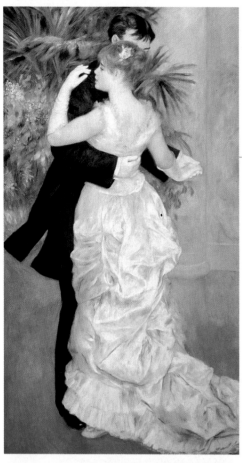

◆ DANCE IN THE CITY (1883, Paris, Museé d'Orsay, detail). The models for this painting are painter Suzanne Valadon and painter friend Paul Lhote. This canvas is one of a trilogy on dance, wholly built upon chromatic contrasts. Here the white dress stands out against the black figure of the man, while the flowers behind the couple mirror the flower in the woman's hair. This is the most refined of the three panels, perhaps because it shows the social environment.

◆ THE LUNCHEON OF THE BOATING PARTY (1881, Washington, Phillips Collection). Renoir began this work at the "La Fournaise" restaurant at Chatou, on the Seine, where the scene is set. Identifiable among the figures are: Alphonse Fournaise, owner of the restaurant; his daughter Alphonsine, leaning against the railings. Sitting at the table: Aline and her dog, actress Ellen Andrée, journalist Maggiolo - behind her - and Caillebotte; in the background, wearing the top hat, banker and collector Charles Ephrussi.

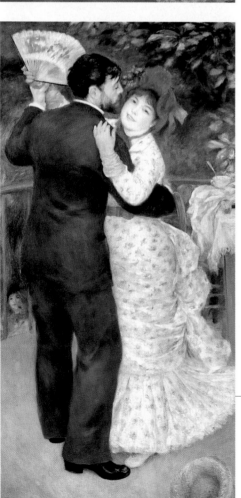

◆ DANCE IN THE COUNTRY (1883, Paris, Museé d'Orsay). Renoir returns to the motif of the *Moulin de la Galette* with these three dance paintings. In this panel, the models are Aline and painter Paul Lhote. Here the chromatic contrasts are the navy of the man's suit against the red and white; the yellow of the straw hat on the ground is repeated in the woman's gloves.

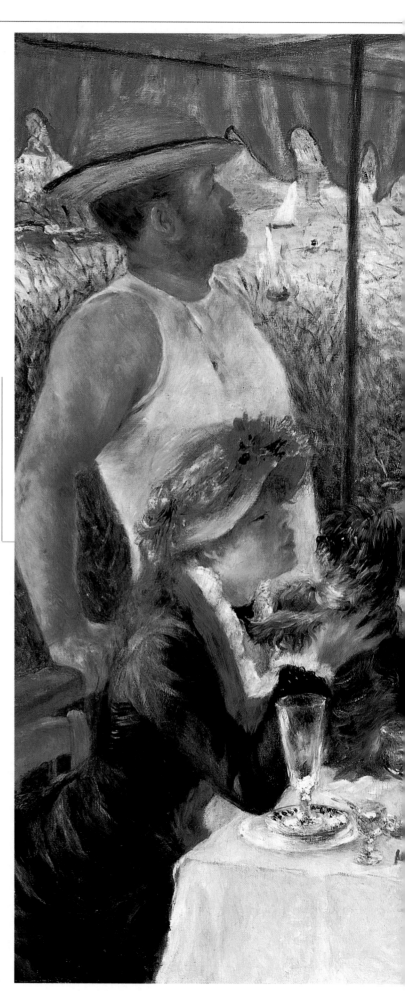

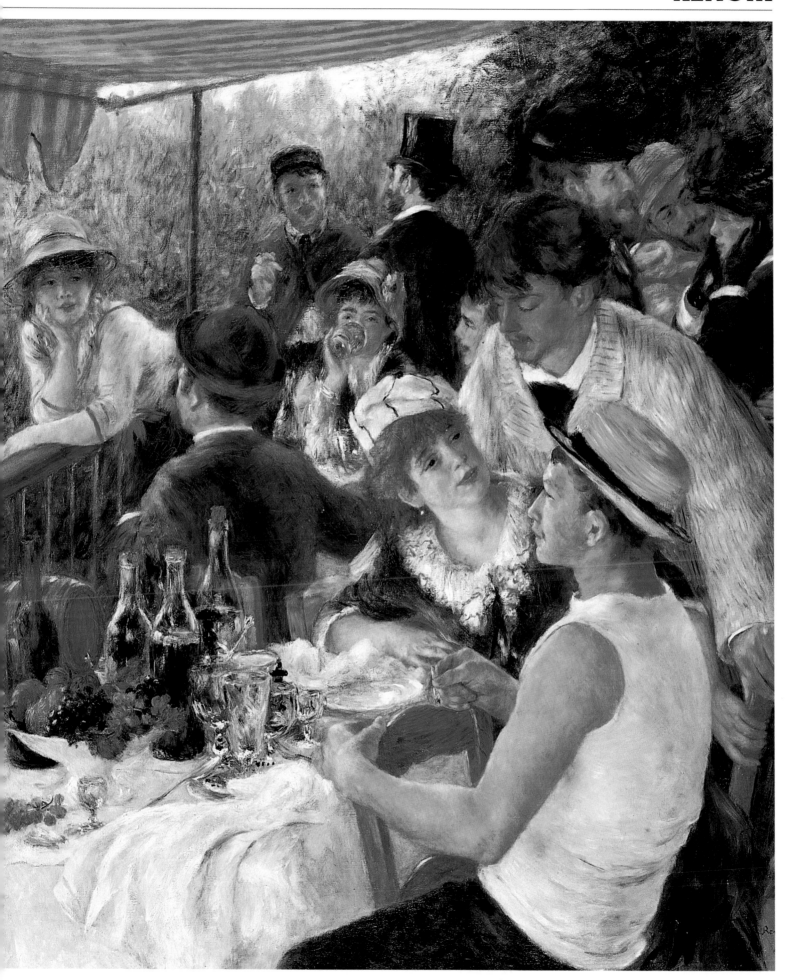

THE NACRÉE PERIOD (1890s)

The term *nacrée* (pearlescent) is applied particularly to Renoir's works of the eighteen nineties. In these canvases, the painter leaves behind his *aigre* style to return to a freer colouristic vision which is, indeed, more congenial to him.

● Renoir's imagination and sensitivity to colour and light could not long be tethered to the drawing templates of the classics as seen through the eyes of Ingres. In 1888 Renoir said, "I have gone back, forever, to my old soft and light way of painting." Volume and surrounding space almost inter-penetrate, outlines fade into one another, while the colours, resolved into thousands of little dabs, take on mother-of-pearl hues as in the eighteenth century masters. Having abandoned the external outline, to some degree Renoir returns to the Impressionist style, though without renouncing his experiences of the *aigre* period, namely monumentality and the classicism of his figures.

● Works such as the *Portrait of Aline*, painted in 1885 - the year in which Renoir's first child was born - and *Mother and Child*, painted in 1888, attempt to reconcile classical composition with direct experience of nature in a style of painting with a light touch,

◆ IN THE MEADOW
(1890, New York, Metropolitan Museum). This painting, with its bold style, takes up a theme very close to the artist's heart. Of note are the chromatic accords between the warm tones of the countryside and the cold tones of the figures. Above, a detail of Jean-Honoré Fragonard's *Bathers* (1761-70, Paris, Louvre). The joy, hedonism and languid grace of Rococo works are softened by Renoir's modern ideal of beauty.

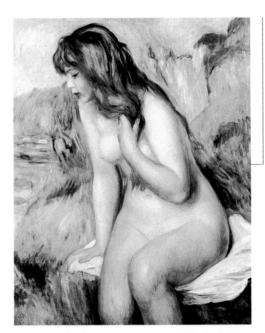

◆ BATHER ON A ROCK (1892, Paris, private collection). The girl's body shows a solid volumetric structure, accompanied by a rendering of the environment based on atmospheric values. In Renoir's later works, his frequent painting of female nudes, monumental in structure yet almost dissolved in the atmosphere, takes on a symbolic reference as an ode to generative nature.

against light-filled backdrops. His brushstrokes have become heavier, more detached, without yet achieving the fusion between light, colour and volume which characterizes his later works.

● This long and fruitful period was interrupted in 1897, when Renoir broke his arm at Essoyes, his wife's village, where he went on holiday every summer, and where he painted landscapes in a fluid and hazy style. Now at the zenith of his career, he no longer had economic worries, but his health began to be severely compromised by arthritic rheumatism. Treatment did little to improve the condition, so he decided to move to a dryer and milder climate than Paris. After a number of trips to the Cote d'Azur, in 1903 he spent the whole winter at Cagnes.

● Renoir continued to travel every summer to Essoyes and Paris, to which he still felt strong bonds. His painting becomes monumental during this physically trying period. But Renoir's classicism is open to experimentation, to the exploration of new artistic experiences, from the emphasis on colour of the Veneto Italians to Rubens, Velázquez, Watteau and Fragonard, all painters who share his sensitivity.

◆ PORTRAIT OF ALINE (1885, Philadelphia, The Philadelphia Museum of Art). It has been said that, unlike in Manet, Renoir's women never possess an intellectual gleam in their eye, they are never on an equal footing with men; what they express is the warmth of their affections, as in this simple, serene figure. Renoir adapts the way the Veneto painters Veronese and Titian, and Raphael, rendered flesh tones, by using the Impressionist technique of little dabs of colour,. The inter-penetration of light and shadow results in a stunning clarity on canvas.

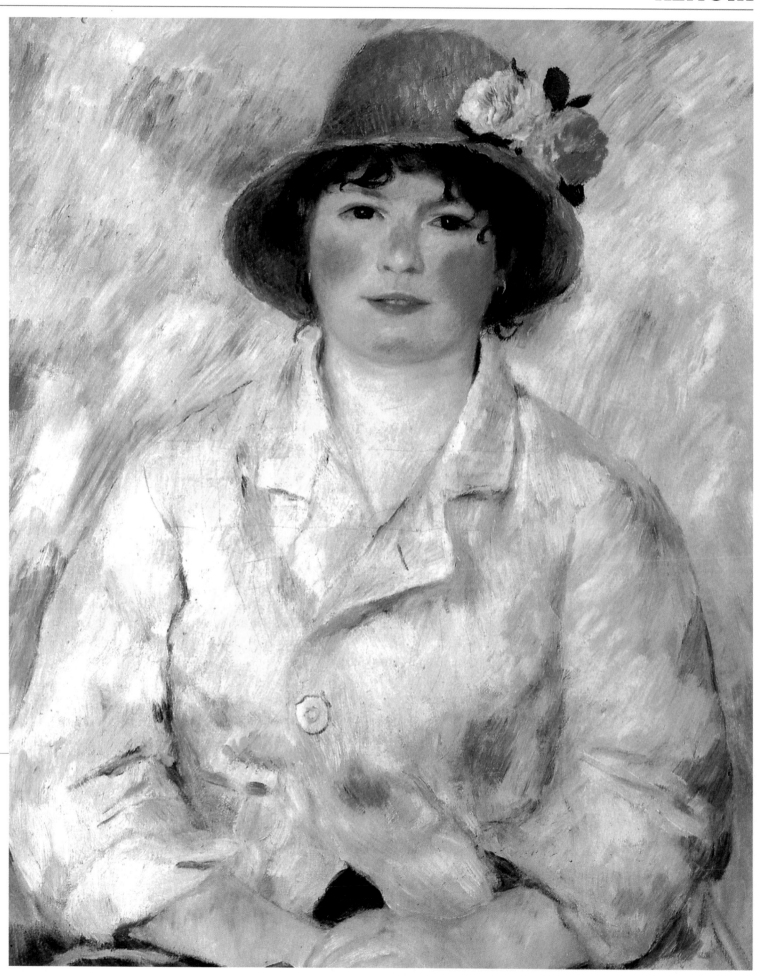

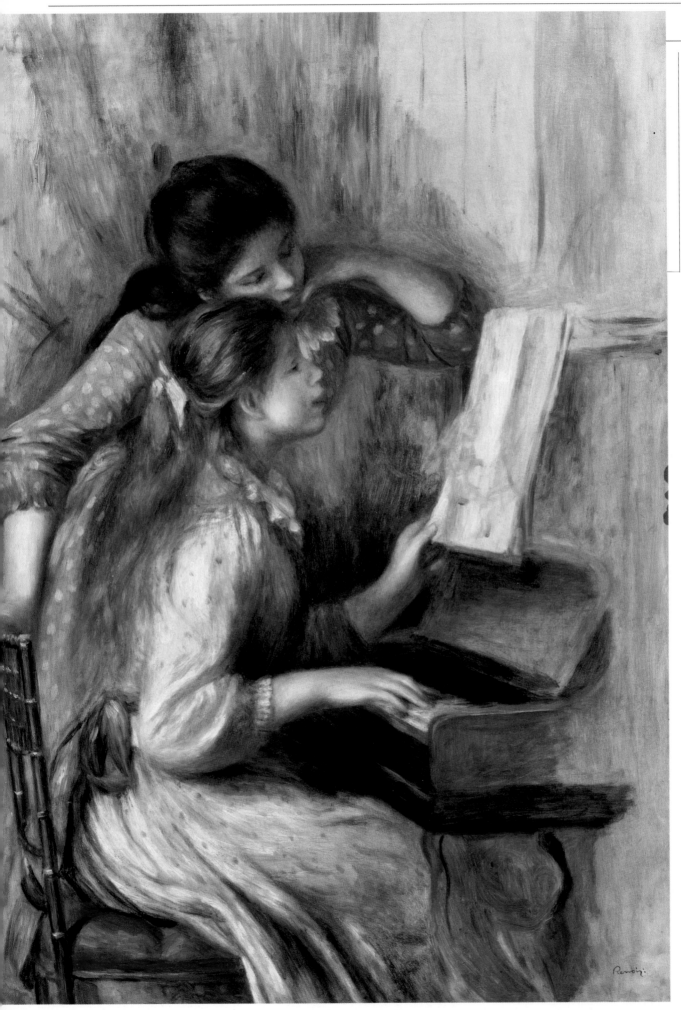

◆ GIRLS AT THE PIANO
(1892, Paris, Musée
d'Orsay).
In his later years,
Renoir dedicated
a number of paintings
and studies to this
subject. His favoured
theme of girls is
twinned with the
theme of music,
giving rise to paintings
of serene domestic
life, in a muted
atmosphere where
suffused and iridescent
light plays on
the human forms,
enveloping them with
the silky effects of the
soft tones of the clothes
and ribbons. Renoir's
suggestive and alluring
pictorial style at this
time was naturally
warmly received by the
bourgeois public, which
saw itself reflected at its
best in these glossy,
mellifluous and graceful
representations.

◆ MOTHER AND CHILD
(1886, New York,
private collection).
Aline is painted at
Essoyes, as she
suckles Pierre,
Renoir's first son.
Though the
composition
does not fully
achieve a fusion
between the
surrounding
environment and
the figures, there is
in any case a balance
between the brilliance
of the colours and
the clarity of outline.
The heightened
significance of
draughtsmanship is
highlighted especially
in the spiral created by
the baby's legs.

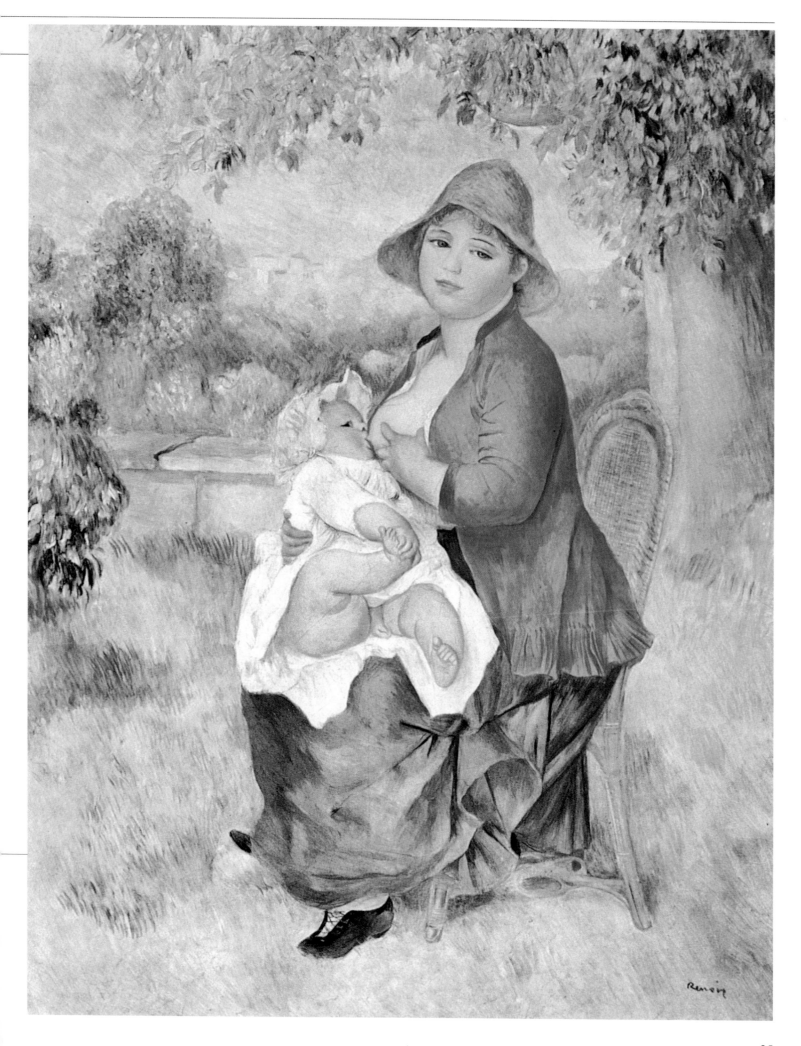

CAGNES, TO THE LAST BREATH

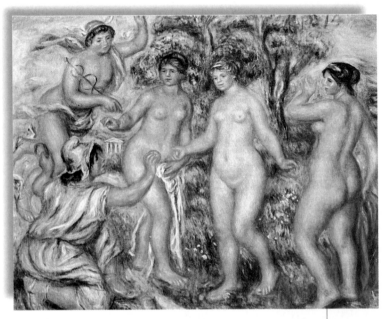

The works Renoir painted at Cagnes, in the last ten years of his life, are far removed from both his *aigre* period and the precious, iridescent brushstrokes of colour of his *nacrée* style. Attracted by the Mediterranean countryside, in the south of France Renoir returned to his love of the classics, as expressed through mythological themes. His compositions are pervaded by cosmic harmony, constituting an anthem to life despite the war, his enforced immobility, and his increasing sufferings. Works of this period include *The Judgement of Paris* (1914), in which Rubens' influence is clear not just on an iconographic level, and female nudes whose carnal softness is accentuated by red-dominated tones. Renoir's palette, at this stage, is dominated by vermilion, geranium, and brown, alongside cobalt blue, emerald green, ochre, white and ivory black.

◆ PIETER PAUL RUBENS
The Judgement of Paris
(1600-01, Vienna, Kunsthistorisches Museum).
Renoir is attracted not just by the composition, but also by Rubens' conception of volume, going so far as to cite the red pall.

● Renoir's frenetic and busy life are surprising. Willpower of Herculean proportions guided the old, ailing artist: he had the brush tied to his hands, now deformed by arthritis, so he could paint right up to the end. His works, still so full of vitality, are animated by an inexhaustible desire for perfection, balance and order. In his last canvases of bathers, dominated by wine-like red hues, the opulent bodies and overladen compositions express a *joie de vivre*, a Dionysian jubilation, which is as much a challenge to his personal suffering as to historical tragedy.

● Renoir said, "I love thick, smooth, oozing painting, I like to touch a painting, to run my hand over it." Indeed, his compositions start with volumes. To begin with, he traces the rough outlines with brown red, for the proportions of the elements which make up the picture. Then, with pure paints diluted with turpentine, he rapidly rubs at the canvas.

● At this point, the idea of the work takes form from the colours even before the outline of the image is defined. In the same manner, once the turpentine has dried a little, the painter adds oil and other colouring material. To finish, he lightens the tones by spreading pure white directly on the canvas.

◆ THE JUDGEMENT OF PARIS
(1914, Hiroshima, Hiroshima Museum).
Inspired by Rubens' painting, this canvas stands out, among other things, for the close-up point of view, and the lighting by the sun. In the oval, a detail from *Cros-de-Cagnes* (1905, private collection).

◆ SEATED BATHER
(1914, Chicago Art Institute).
"When I look at a nude body and I see myriad nuances, I have to decide which ones will yield to the canvas the live, throbbing flesh." - this is how Renoir describes his ceaseless quest.

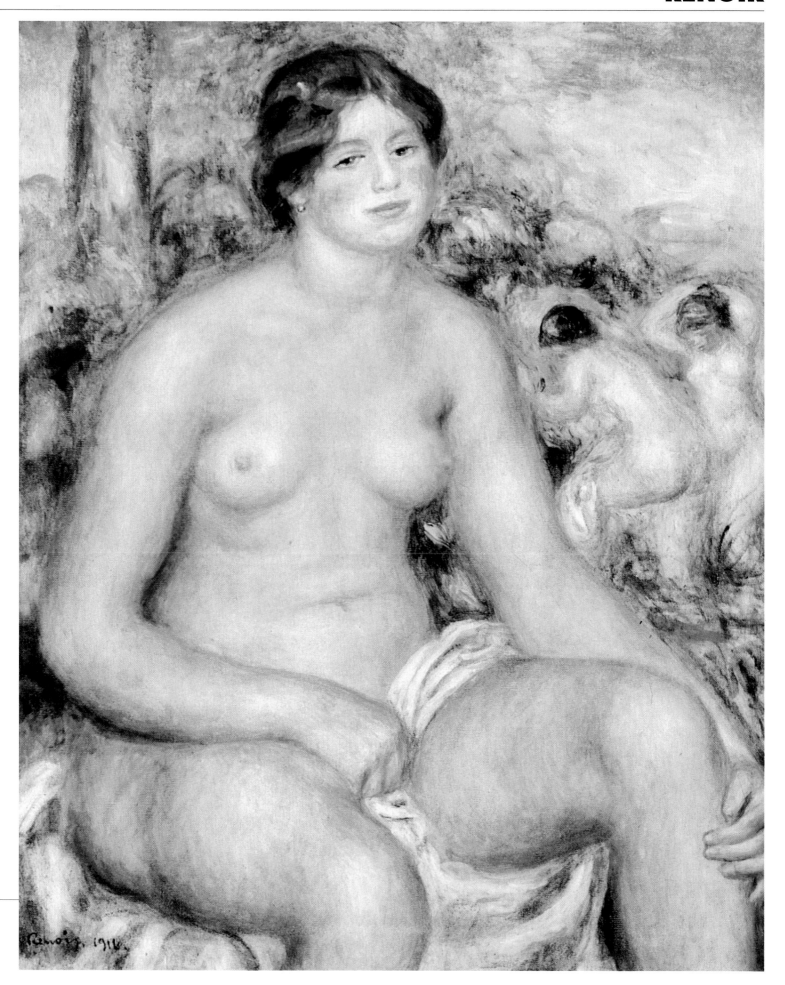

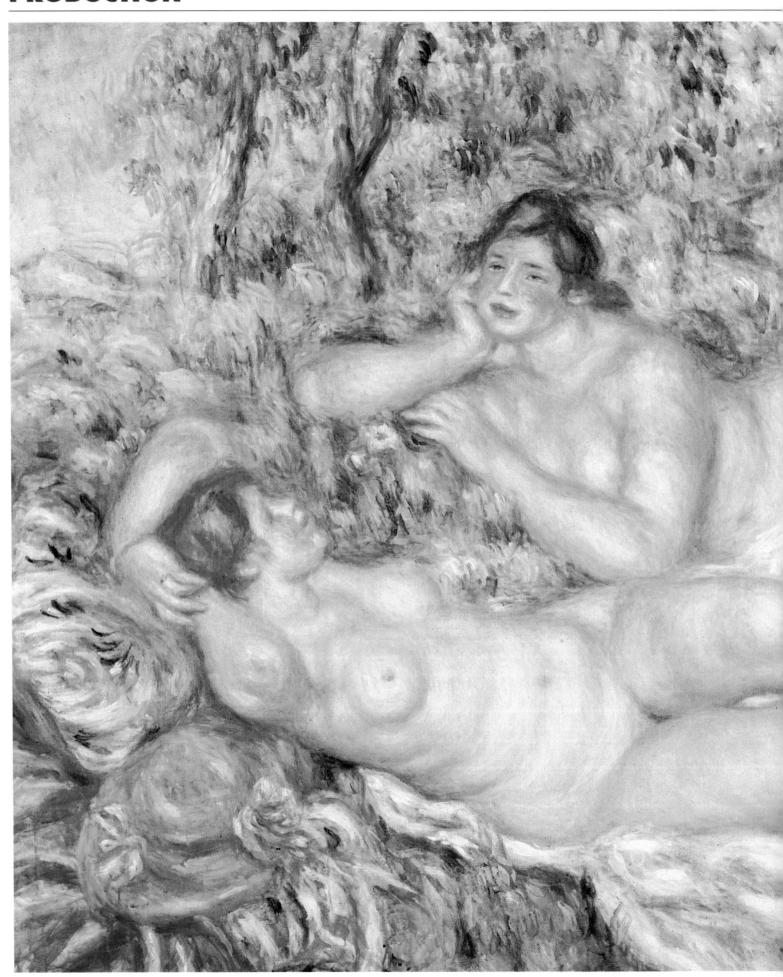

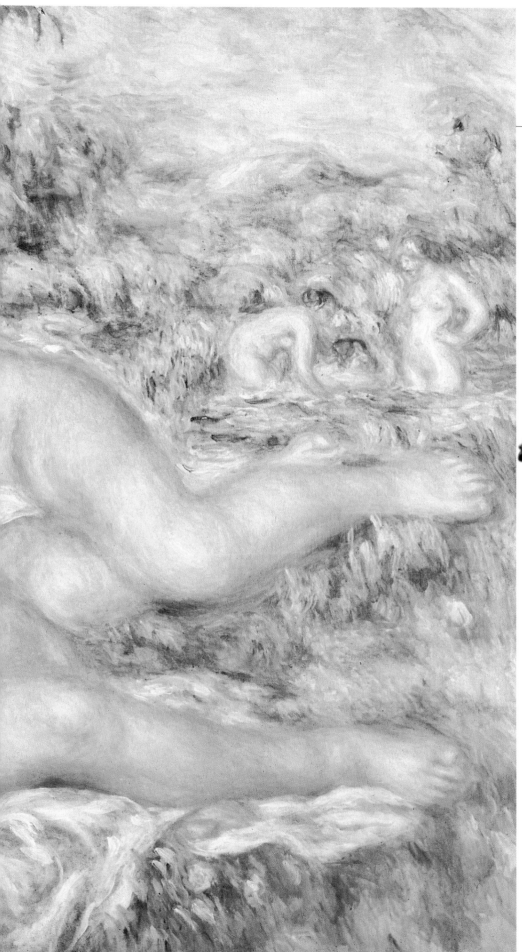

◆ BATHERS
(1918-19, Paris, Musée d'Orsay).
What is striking about this work of his late period in Cagnes, is the perfect blending of the figures and the setting. The softly reclining women have lost their outlines, they are totally immersed in the landscape and the luminous atmosphere. Renoir's reference models are easily identifiable with Rubens and Titian, yet here they are reinterpreted in a modern key, encapsulating an Impressionist perception of light. Renoir goes beyond the dichotomy of studio and *en plein-air* work: the nudes are idealized, the graceful figures of preceding figures become monumental, while the settings conjure up fantastical atmospheres, full of vibrating light. "I'm doing *en plein air* in the studio," Renoir told his painter friend Berthe Morisot.

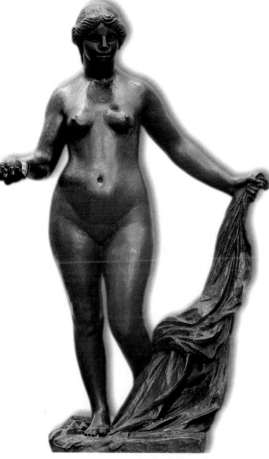

◆ VENUS VICTORIOUS
(1910, London, Tate Gallery).
During this period, Renoir dedicated himself to sculpture, perhaps because painting no longer sufficed to express the physicality of the human body, to render its weight, without deforming the models; or perhaps because, right up to the end, he continued to ceaselessly seek out new forms of expression. From his wheelchair, with the help of a rod, he guided the work of a young Catalan apprentice - Richard Guino, a pupil of Maillol – who translated the artist's last images into bronze, creating veritable masterpieces of modern sculpture.

RENOIR'S FRIENDS

Impressionism appeared at a time when politics was breaking apart the Second Empire, the upper-middle classes (bourgeois) were becoming prosperous, industrial development was moving apace, and enormous technological and scientific strides were being taken. The Impressionists' natural audience was the bourgeoisie, and after their initial rejection, it was this class which bought most of their paintings. Scientific research into physiology and the psychology of perception moved ahead at the same speed as the painter's experiments with light, colour and physical movement. The physicist Chevreul's discoveries about simultaneous contrast and complimentary colours, published in 1839, laid the scientific foundations for Impressionist theories. Renoir gave pride of place in his studio to a chromatic circle, which he used for colour matching and combination.

● The Franco-Prussian war of 1870 scattered Renoir's group of friends: Manet became a staff officer in the National Guard; Pissarro, Sisley and Monet sheltered in England; Cézanne took refuge in Aix-en-Provence; Bazille, Renoir and Degas were drafted. Manet died on the front, and Renoir's grief for his friend's death cast a veil of melancholy over his works during 1871. During their stay in England, Pissarro and Monet met Durand-Ruel, owner of a gallery in Paris, and later New York. Already an admirer of Barbizon school landscapists, the art dealer was one of the first to recognize the importance of this new

◆ PORTRAIT OF FRÉDÉRIC BAZILLE (1867, Paris, Musée d'Orsay). A great friend of Renoir's, the painter is portrayed in his studio at 20, Rue Viscount, as he is painting *The Heron*, a picture Manet much admired for its freer structure than evident in earlier works. Bazille died in 1870, too young to join Renoir on his Impressionist journey.

style of painting. A number of collaborations and exhibitions resulted from this meeting, ultimately spreading the word about Impressionism as far as America.

● Parisian publisher Charpentier, who promoted the naturalist writers, and whose salon was frequented by Maupassant, Hugo and Zola, was politically one of the opponents of the Second Empire, alongside Gambetta, Clemenceau and Geffroy. Charpentier boldly defended the Impressionists from the first critical attacks, though he soon showed that he had not understood them properly, and ceased to have much to do with them.

◆ THE ENGAGED COUPLE: ALFRED SISLEY AND HIS WIFE (1869, Cologne, Wallraf-Richartz Museum). Painted in Renoir's early Courbettian style, this work depicts his friend, painter Alfred Sisley, with his wife Marie. Left: a photograph of Renoir at Cagnes.

◆ MADAME MONET
READING
(1874, Lisbon,
Gulbenkian Museum).
During this year Renoir
made several portraits
of Madame Monet and
her son, and often
painted in the painter's
garden. Structurally,
the composition
revolves around the
diagonal of the
woman's pose;
chromatically, it
centres on the contrast
between the azure and
ochre of her dress.

◆ CLAUDE RENOIR
(1907, Paris, Musée
Marmottan).
This plaster medallion
depicts the artist's son -
known affectionately as
'Coco' - born on 4
August 1901 at Essoyes.
Already afflicted by
rheumatism, and 60
years old, Renoir
considered his third son
to be a divine blessing,
and his birth brought
renewed vigour to the
artist's painting. In
1907, Renoir executed
an intense sequence
of portraits of Coco.

◆ THE NEPTUNE
On 19 July 1870,
Napoleon III
declared war on
Prussia. After an
initial victory,
on 2 August
the French suffered
a series of defeats,
culminating,
on 18 August, with
the rout at the Battle
of Gravelotte. In the
photograph, the *Neptune*
balloon, used to
transport mail during
the siege of Paris.

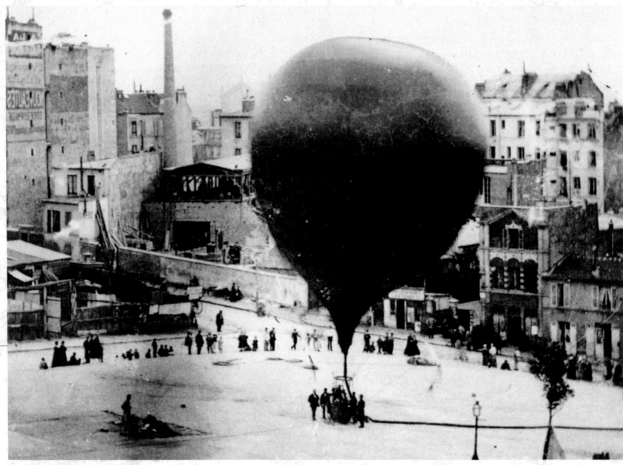

FROM POST-IMPRESSIONISM TO THE INFORMAL

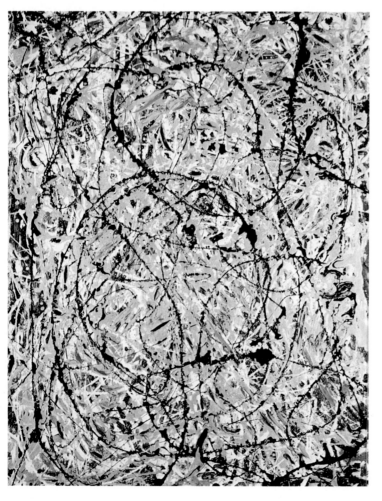

Renoir's works have been studied and admired much more by artists, particularly in the twentieth century, than by critics and art historians. It is common knowledge that the works of the Post-Impressionists - the *pointillisme* of Paul Signac (1863-1935) and Georges Seurat (1859-91) - developed from the Impressionists in general, from their predilection for pure colour applied in dabs, spots or swirls, and their fascination with the representation of light. From Renoir in particular, the Post-Impressionists took up the representation of scenes from every-day life on large canvases. Seurat's *Grande Jatte* is unthinkable without the precedent set by *Moulin de la Galette*.

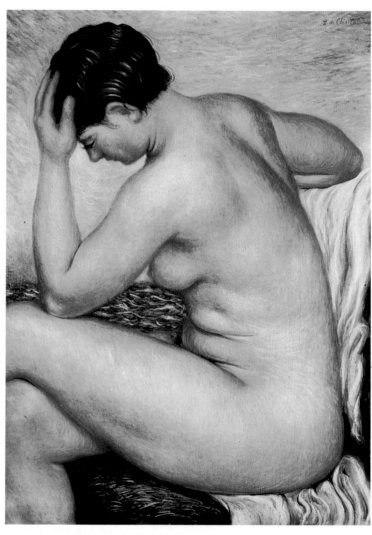

● Testimony to Renoir's enormous influence on the next generation of artists was a visit by the young Henri Matisse (1869-1954) to Renoir's home in Cagnes, the admiration of Pierre Bonnard (1867-1947), the esteem of Pablo Picasso (1881-1973), and the keen observations of Umberto Boccioni (1882-1916). The fluid, monumental painting of his Cagnes works served as a lesson for Giorgio de Chirico (1888-1978), who was inspired by Renoir's style for his own brand of classicism, drenched in light and movement.

● The works of the Impressionists, their conception of painting as a purely visual phenomenon, without restriction in choice of subject, not to mention their experimentation with colour, served as a starting point for modern trends in art, such as the Informal movement and Action painting.

♦ PIERRE BONNARD
Morning Toilette
(1914, Paris, Musée
d'Art Moderne).
Monet and Renoir's
development of
a style of painting
based on perceptive
values lives on in
Bonnard in an
internalized version,
enhanced by the
resonance of
psychology and
memory. It is no
coincidence that the
female nude, so
beloved of Renoir,
is here depicted
in the mirror, hinting
at a self-enquiry
and introspection.

♦ GIORGIO DI CHIRICO
Seated Nude
(ca. 1929, private
collection).
De Chirico's debt to
Renoir's bathers is
evident in the
iconography and
structure of this nude.
In the oval: Georges
Seurat, *Sunday Afternoon
on the Island of La Grande
Jatte* (1884-86, Chicago
Art Institute, detail).
The artist is seeking
a reinterpretation
of Impressionism,
softened by residual
romantic elements,
from the scientific
viewpoint of
optical vision.

♦ JACKSON POLLOCK
Undulating Paths
(1947, Rome, Galleria
Nazionale d'Arte
Moderna).
Pollock and his *dripping*
technique are the
extreme conclusion
of the Impressionist
revolution. The use
of pure colour in blots,
the technique of
chromatic dabs which
are separate and free
of the canvas, and the
painting of surfaces,
were the foundations
of modern informal art.

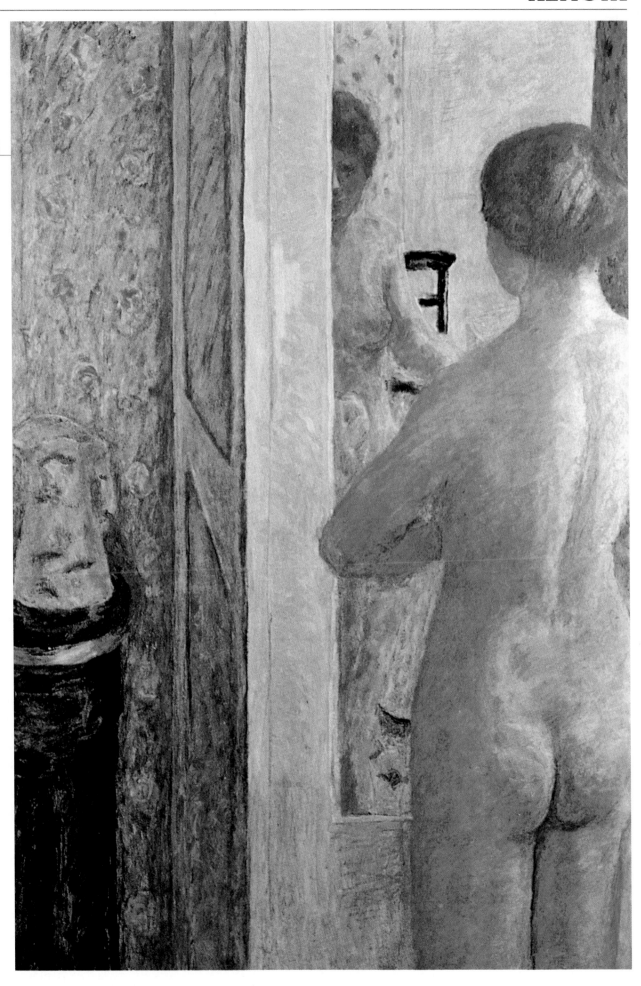

THE ARTISTIC JOURNEY

For a vision of the whole of Renoir's production, we propose here a chronological reading of his principal works.

◆ THE INN OF MOTHER ANTHONY (1866)

Painted at Marlotte, a town near Fontainebleau, where Renoir met Courbet, this work evokes the typical comradeship of the countryside places where the artists went to paint *en plein-air*. The canvas features Renoir, or perhaps Monet, sitting opposite; Jules Le Coeur, standing up; and Sisley, with the *L'Evénement* newspaper in which at the time Zola was writing articles in defence of the Impressionists.

◆ DIANA (1867)

Rejected by the *Salon* in 1867, like the preceding painting this work shows the strong influence of Courbet, made more explicit here by the presence of the dead deer - a cypher of Courbet's - at the feet of the goddess. The artist's embrace of female models and modern techniques, such as applying paint with a spatula, does not prevent him from continuing to present himself at the *Salon* as a pupil of Gleyre's.

◆ GRENOUILLÈRE (1869)

This painting portrays a modern subject: the *péniche* (bar, restaurant and bathing establishment) on the Seine. This is an early attempt to capture the effects of light on water. Renoir features the leisure spot near Paris, where he often went with Monet, in a number of paintings.

◆ ODALISQUE (1870)

Back from the front, where he lost his friend Bazille, Renoir was one of the very few artists not to forsake Paris. This work, presented at the *Salon* of 1870, displays the veil of sadness left by the war. An evident homage to the masters of the preceding generation, Ingres and Delacroix in particular, this is the first of a series of pictures which are oriental in taste, characterized by an intense emphasis on colour.

◆ PONT NEUF (1872)

This bright, radiant picture is the most limpid backlit painting ever executed; it demonstrates an important aspect of Impressionist painting, picked up on by Zola: an interest in city life and the bustle of the streets. Defined as a "painter of modern life," Renoir executed this view from a first floor window, while his brother Edmond stopped passers-by to ask the time.

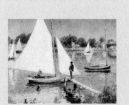

◆ SAILS ON THE SEINE AT ARGENTEUIL (1873)

Argenteuil is one of the places where Impressionism developed. Renoir and Monet often went there together to paint the same subjects; Monet built himself a floating studio on the Seine. The landscape displays the artist's wholly Impressionist style. His palette is lighter, the brushstrokes are rapid and distinct, while the colours are broken up into little dabs.

◆ PATH CLIMBING THROUGH LONG GRASS (1874)

Compared to earlier works, Renoir's touch is lighter, as is his palette of colours, adopting a technique which can truly be defined as Impressionist. The two figures and the landscape are spots of colour, vibrating in the very light and atmosphere. The image which falls on the retina is pure surface, without any aim at spatial illusion.

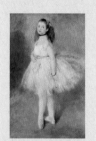

◆ DANCER (1874)

Presented at the first exhibition of Impressionists held by the photographer Nadar, this painting provoked harsh criticism. The Dancer's legs were said to be "limp." Although the atmospheric softness of Renoir's painting - taking up the traditions of 18th-century French painting - was well-regarded in the refined transition of tone which makes up the veil, the same process of dissolving form was not tolerated in the human figure.

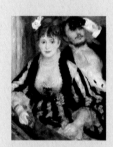

◆ THE THEATER BOX (1874)

This picture, one of seven exhibited at the first Impressionist exhibition in 1874, was acquired by "Père" Martin. The work is striking in the clarity of its colour scheme, built upon strong contrasts between light and dark tones, uniting the two figures - his brother Edmond and friend Nini - in a radiant atmosphere which seeps into the outlines of the bodies. "Black," according to Renoir, "is the King of colours!"

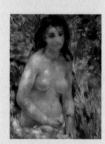

◆ NUDE IN SUNLIGHT (1875)

Exhibited at the second Impressionist exhibition, 1876, the critic Wolff described this painting as, "a pile of decomposing flesh with green and violet welts." Large spots of light and shadow, an important feature of Renoir's works during this period, also characterize his nudes *en plein-air*. Renoir keenly focuses on the effects of lighting in his paintings, allied to an almost tactile depiction of his subjects.

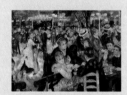

◆ MOULIN DE LA GALETTE (1876)

A work of full stylistic maturity, in this painting Renoir demonstrates his skill in orchestrating a large number of characters through an Impressionist use of colour and light: atmospheric mobility, rendered in the iridescent fluidity of the vibrations of colour, and in the variety of outdoor encounters. A number of Renoir's painter friends posed for the picture, as in a snapshot, conveying the joy of the event.

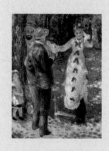

◆ THE SWING (1876)

Executed in Renoir's garden at Rue Corot, this painting belongs to the same period as the *Moulin de la Galette*. Renoir's major conquest was his discovery that shadow only exists as colour, while light dissolves the tones, creating brighter surface areas.

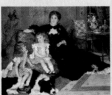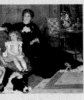

◆ MADAME CHARPENTIER
AND HER CHILDREN (1878)
Presented at the *Salon* of 1879, which Renoir pre-
ferred to the third Impressionist exhibition, this
work marks the gradual establishment of the painter
among the educated bourgeoisie of Paris, to which
Mme Charpentier belonged. Her husband pub-
lished Zola, Hugo and Flaubert. This portrait was
much admired by Belgian writer Huysmans.

◆ LA CASBAH (FÊTE ARABE) (1881)
This work was painted on Renoir's first journey to Al-
geria. Following in the footsteps of Delacroix, Renoir
plunged into the bright and radiant atmospheres of
North Africa, perhaps in an attempt to overcome a pe-
riod of creative crisis. In this painting, acquired by Mon-
et in 1900, light is the dominant colour, marking the
development of the composition, which is viewed
from above and organized along diagonals.

◆ BLOND BATHER (1881)
Painted during a tip to Italy, this picture reveals the
influence of Raphael's painting on Renoir, both in
its triangular composition, and in the type of fem-
inine beauty, clearly drawn from the *Galatea*, paint-
ed by the artist from Urbino, Italy. The subject has
been revisited through Ingres, a French painter to-
wards whom many later painters - Renoir includ-
ed - felt a certain inferiority complex.

◆ DANCE IN THE CITY (1883)
Renoir tackles the subject of dance in three panels.
These pictures mark the beginning of a crisis period,
as he distances himself from the Impressionist style
and returns to realistic values of representation. This
is Renoir's so-called *Ingresque* period, characterized by
his pursuit of the volume of bodies and, as in this pic-
ture, balance between the luminosity of the few
colours used and the strict sharpness of form.

◆ PORTRAIT OF ALINE (1885)
Aline Charigot, first Renoir's model, then his
wife, gave birth to the painter's first son in
1885. This work belongs to his *Ingresque* peri-
od, which the painter himself referred to as *ai-
gre*, because of his palette dominated by acidic
hues and cold colours.

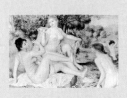

◆ THE BATHERS (1884-87)
"I believe it is impossible to achieve a greater ex-
pressive power of form in a drawing," said Berthe
Morisot on viewing Renoir's studies for *The Bathers*
during a visit to the artist's studio. Painted in the
studio, this work was exhibited in 1887 subtitled,
"Study in decorative painting," a reference to
the technical and manual dimension the artist be-
lieved art required.

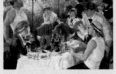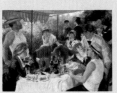

◆ THE LUNCHEON OF THE BOATING PARTY (1880-81)
Renoir's second composition, after the *Moulin
de la Galette*, to present a major scene filled with
people. Unlike the earlier work, here the people
are clearly recognizable: his companion Aline,
with her dog; the actress Andrée, behind whom
is the journalist Maggiolo; the painter Caille-
botte, wearing a hat. A more incisive approach re-
sults in the faces being well-defined.

◆ UMBRELLAS (1880-83)
This work is a typical Renoir "scene from modern
life." Probably executed in two stages - the left-
hand side is the later portion - the painting shows
Renoir's transition from the Impressionist style to
a new departure. Of note is the serpentine rhythm
created by the curves of the umbrellas, creating
an illusion of space. The colours here are the dry
and acid tones of his *aigre* period.

◆ GIRLS AT THE PIANO (1892)
This work was commissioned especially for the
Luxembourg - a public art museum exhibiting the
works of living artists - by its director Henry
Roujon, on the recommendation of Mallarmé and
Roger Marx. The painting contains evident con-
cessions to bourgeois taste, with a tendency to ex-
cessive sentimentalism, though it marked the de-
finitive success of the artist in the market.

◆ BATHER ON A ROCK (1892)
Nudes, described by Renoir as, "an indispensable
form of art," are plentiful in his later output. Dur-
ing this period the painter abandoned topics of
everyday bourgeois life in favour of Edenic loca-
tions. Prone to an expression of Olympian seren-
ity, attracted by examples from the past (Rubens
and Titian), the synthetic form of his bodies are in-
spired by ideals of classical beauty.

◆ CROS-DE-CAGNES (1905)
In his late works and landscapes at Cagnes,
Renoir admirably rendered the quality of light and
nature of southern France. This canvas is a typ-
ical view, executed in a condensed style. After
falling in love with the place and its mild climate,
as his crippling arthritis progressed, in 1907 the
painter bought the Les Collettes estate at Cagnes-
sur-Mer, not far from Nice.

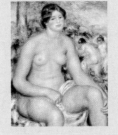

◆ CLAUDE RENOIR PLAYING (1906)
Claude Renoir, the painter's youngest son, became
one of his favourite models. During these years he
often painted him in the most spontaneous pos-
es, outdoors and indoors. In this painting the
background is merely sketched, while our focus
is squarely on the child; fiery hues of red pre-
dominate, only slightly tempered by the white
notes of the cuffs, ribbon and toy soldiers.

◆ SEATED BATHER (1914)
The balanced structure of this painting centres on
the opulent and monumental body of this bather,
which completely fills the foreground. With his
Cagnes works, Renoir achieved a perfect harmony
of figure, volume and environment, composing his
nudes as a large mass of volumes under full
light, living matter itself, coming to life with the
very regenerative energy of nature.

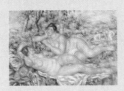

◆ BATHERS (1918-1919)
This work marks the conclusion of 30 years of
endeavour. The insertion of these figures in
the landscape is perfectly achieved even in its
details, for example the cushion, which is in-
distinguishable from the vegetation. This work
is the spiritual legacy of an artist who developed
his own personal artistic path out of the Im-
pressionist style.

TO KNOW MORE

The following pages contain: some documents useful for understanding different aspects of Renoir's life and work; the fundamental stages in the life of the artist; technical data and the location of the principal works found in this volume; an essential bibliography.

DOCUMENTS AND TESTIMONIES

Early praise

"Renoir may rightly be proud of his ball [the *Moulin de la Galette*]: never has he been more inspired. This is a page of history, a valuable monument to Paris life, of the strictest fidelity. Nobody before him had thought of capturing a moment of everyday life on such a large canvas; his is a bold move which success shall reward as is fitting.

This painting will have a major impact on the future, which we are here to point out. This is an historic picture. Renoir and his friends have understood that historic painting is not the more or less whimsical illustration of pictures from the past; they have forged a path which others will certainly follow. Let those who wish to execute historic paintings tell the story of the age, instead of kicking up the dust of centuries past... Handling the subject through tones, and not via the subject itself, this is what sets the Impressionist apart from other painters... It is this pursuit above all else, this way of portraying a subject, which is Renoir's personal quality; rather than seek the secret of the Masters - Velázquez or Frans Hals - as do the *enfants volontaires* at Quai Malaquais, he has sought to make a contemporary mark, and the *Ball*, whose colour is so full of appeal and innovation, will without doubt be the big hit of this year's painting exhibitions."

[G. Rivière, in *L'Impressionniste*, 1877]

His brother's acclamation

"Living outdoors, [Renoir] has become the *plein-air* painter. The four cold walls of an *atelier* have not weighed him down, nor has the uniform grey of building walls blocked his eye. The outside environment has an enormous influence on him; he has no memory of the slavery into which all too often artists cast themselves; rather he allows himself to be transported by his subject, and especially by the environment in which finds himself.

This is the peculiar nature of his work. It is everywhere and always: from *Lise*, painted in the middle of the forest, to his *Portrait of Madame Charpentier and Her Children*, painted at her home, without even shifting the furniture from where it stands everyday; without anything being prepared to give emphasis to one or another part of the picture.

Painting *Moulin de la Galette*? Why, he set himself up there for a full six months, he formed a relationship with that little world with its typical appearance, which posed models could never recreate; and then, he plunged into the swirl of that popular party, he rendered the frenzied movement with stunning verve.

Painting a portrait? He asks his sitter to behave normally, to sit as they usually do, to wear what they normally wear...

What he has painted is what we see everyday; it is our very existence, recorded in chapters which will most certainly remain among the most lively and harmonious of the age."

[E. Renoir, in *L'Arte Moderne*, 1879]

His son's memories

"Almost always, he mixed his colours on the canvas. At all stages of his work, he was highly concerned about maintaining an impression of transparency. I have already said that he worked across the entire surface of the canvas, and that the subject appeared from within the apparent confusion of all those brushstrokes, just as a photographic image appears on a plate.

I have also drawn the reader's attention to the silvery white layer applied to the canvas before he began to apply his colours; he used to ask the model or the son he had appointed to help him, to increase the proportion of linseed oil. For this reason, the white took several days to dry, but then it offered Renoir a smoother surface. He did not like refined canvas, which was easier to paint on, as he believed it to be less resistant."

[J. Renoir, *Renoir My Father*, Paris, 1962]

A chat with Vollard

"Renoir ushered me into a room which was not at all striking; an easel, two or three unmatched pieces of furniture, a profusion of fabric, and a few straw hats which the painter enjoys folding and unfolding before posing his models. Paintings lie in every corner: close by the model's seat, I saw a pile of copies of the avant-garde "Revue Blanche" magazine.

'This,' I ventured, 'is an interesting publication.'
'So it is, by Jove! My friend Natanson sent it to me.'

When he saw me stretch out a hand to pick up a copy, Renoir stopped me:
'Don't touch them, I put them there for the model to rest her foot.' "

[A. Vollard, *Quadri in vetrina*, Paris, 1919]

A letter to Durand-Ruel

"I have kept my distance from all painters, in the sun, all the better to reflect... I believe I have reached my destination and found what I was looking for. My arrival at the *Salon* is purely commercial... I do not wish to leave Algiers without bringing back something of this marvellous country."

[A. Renoir, letter to P. Durand-Ruel, Algiers, March 1881]

1841. On 25 February Pierre-Auguste Renoir, son of a tailor and worker, is born in Limoges.

1844. The family moves to Paris.

1848. At the School of the Brotherhood of Christian Schools, the young Renoir distinguishes himself in painting.

1854. He enters the Lévy porcelain factory as a decorator. In the meantime, he attends evening courses given by the sculptor Callouette at the École de Dessin et d'Arts Décoratifs.

1858. After the factory closes down, he continues to decorate porcelain, fans, and cupboards, as well as painting coats of arms for his brother, who casts medals.

1859. He paints subjects on behalf of the painter Gilbert, for missions.

1860. He is enrolled on the register of professional artists authorized to make copies at the Louvre. His favourites are Rubens, Fragonard and Boucher.

1862. He leaves Gilbert and attends Gleyre's courses at the École des Beaux-Arts, together with Sisley, Monet and Bazille.

1864. He is admitted to the Salon with *Esmerelda Dancing*. His family moves to Ville-d'Avray, but Renoir stays on in Paris, first with Sisley, then with Bazille, with whom he also shares a studio.

1865. He paints *en plein-air* in the forest at Fontainebleau with Sisley, Pissarro and Monet. In the town of Marlotte, where he is staying, he meets Courbet and strikes up a relationship with Lise Tréhot, his companion and model until 1872.

1866. At Marlotte he paints *The Inn of Mother Anthony*. He is rejected by the Salon.

1867. His *Diana* is rejected by the Salon. He works at Bazille's studio. He frequents the group that congregates around Manet at the 'Café Guerbois', in the Batignolles district.

1868. He is invited to be part of the Salon with *Lise with a Parasol*.

1869. He works with Monet at the Grenouillère.

1870. He attends this year's Salon with *Bather with a Griffon* and an *Odalisque*. He is called to arms for the Franco-Prussian war; he returns to Paris in March 1871.

1872. Together with Monet, who has returned from London, he paints on the banks of the Seine at Argenteuil.

1873. With painter friends he co-founds the *Société Anonyme des Artistes, peintres, sculpteurs, graveurs*.

1974. Between 15 April and 13 May the *Société Anonyme des Artistes* holds its first exhibition for the group at the studio belonging to photographer Nadar. Renoir exhibits seven works, including *The Theatre Box*.

1875. He arranges an auction of unsold works from the Nadar exhibition at the Hôtel Drouot.

1876. At the second Impressionist exhibition, Renoir exhibits 15 works. He meets the financier Cernuschi and banker Ephrussi, both of whom are collectors. He paints *Moulin de la Galette*.

1877. He exhibits 20 works at the third Impressionist exhibition, including *Moulin de la Galette*.

1879. He does not exhibit at the fourth exhibition of the group, but he is accepted at the Salon with his *Portrait of Jeanne Samary* and *Madame Charpentier and Her Children*. A first personal exhibition is held at the "La vie moderne" gallery. He becomes romantically attached to Aline Charigot, who models in many of his paintings.

1880. He declines to join the fifth Impressionist exhibition and exhibits instead, with success, at the Salon. He paints *The Luncheon of the Boating Party*.

1881. He does not take part in the sixth Impressionist exhibition. He travels through Algeria and Italy, where he is struck by Raphael and the paintings of Pompeii.

1882. He meets Wagner in Palermo, and paints his portrait. On his return to Paris he passes through Estaque to visit Cézanne. Some of his canvases, owned by art dealer Durand-Ruel, are on show at the seventh Impressionist exhibition.

1884. Renoir dreams of establishing a new association of painters: the *Société des Irrégularistes*. At Wargemont, as a guest of Bérard, he paints *Children's Afternoon at Wargemont*.

1886. He stays away from the last Impressionist exhibition, but has 28 paintings at the group's New York exhibition, organized by Durand-Ruel.

1887. He exhibits *The Bathers*. He becomes friends with Mallarmé, whom he meets at the home of Berthe Morisot.

1890. Exhibitions of his works are organized by Durand-Ruel in Brussels and Paris. Renoir marries Aline Charigot.

1892. A major retrospective exhibition is organized by Durand-Ruel.

1897. He travels abroad to London, The Hague, Bayreuth and Dresden.

1898. He is afflicted by serious rheumatism.

1900. He is awarded the Legion of Honour.

1904. He exhibits at the Salon.

1907. He buys the estate at Les Collettes, near Nice, and moves there the following year.

1911. Despite his deforming arthritis, which constrains him to a wheelchair, he continues to paint by tying a brush to his hand.

1914. Attracted by sculpture, he creates 15 works, materially executed by Richard Guino.

1915. His wife Aline dies. She was mother of their three children: Pierre, Jean (later to become a famous director) and Claude.

1919. Renoir dies on the night of 2 December.

The following is a listing of the technical data for the principal works of Renoir that are conserved in public collections. The list of works follows the alphabetical order of the cities in which they are found. The data contain the following elements: title, dating, technique and support, size expressed in centimeters.

ALGIERS (ALGERIA)
Spring,
1877; oil on canvas, 38x53;
Musée des Beaux-Arts.

BERLIN (GERMANY)
Girl Sitting Outdoors (Summer),
1869; oil on canvas, 85x62; Nationalgalerie.

CHICAGO (USA)
Lunch on the Riverbank,
1881 ca.; oil on canvas, 54x65;
Chicago Art Institute.

COLOGNE (GERMANY)
The Engaged Couple:
Alfred Sisley and his Wife,
1868; oil on canvas, 105x75;
Wallraf-Richartz Museum.

ESSEN (GERMANY)
Lise with a Parasol,
1867; oil on canvas, 184x115;
Museum Folkwang.

CAIRO (EGYPT)
Woman with a White Bow,
1882; oil on canvas, 55x46;
Musée Mahmoud Khalil.

LISBON (PORTUGAL)
Madame Monet Reading,
1874; oil on canvas, 54x73;
Musée Gulbenkian.

LONDON (ENGLAND)
The Theatre Box,
1874; oil on canvas, 80x64;
Courtauld Institute.

Her First Evening Out,
1876; oil on canvas, 65x50; National Gallery.

Umbrellas,
1880-83; oil on canvas, 180x115;
National Gallery.

MERION (UNITED STATES)
Woman at the Source
1875; oil on canvas, 130x78;
Barnes Foundation, Museum of Art.

Jeanne Durand-Ruel,
1875, oil on canvas, 112x75;
Barnes Foundation, Museum of Art.

MUNICH (GERMANY)
Woman in Black,
1876; oil on canvas, 60.4x40.4;
Neue Pinakothek.

MOSCOW (RUSSIA)
Seated Nude (Anna's Torso),
1876; oil on canvas, 92x73; Pushkin Museum.

NEW YORK (UNITED STATES)
Madame Charpentier and Her Children,
1878; oil on canvas, 153x189;
Metropolitan Museum.

PARIS (FRANCE)
The Seine at Argenteuil,
1873; oil on canvas, 46.5x65; Musée d'Orsay.

Nude in Sunlight,
1875; oil on canvas, 80x64; Musée d'Orsay.

The Swing,
1876; oil on canvas, 92x73; Musée d'Orsay.

Moulin de la Galette,
1876; oil on canvas, 131x175; Musée d'Orsay.

Dance at Bougival,
1882-83; oil on canvas, 180x98;
Musée d'Orsay.

Dance in the Country,
1883; oil on canvas, 180x90; Musée d'Orsay.

Dance in the City,
1883; oil on canvas, 46x26; Musée d'Orsay.

Girls at the Piano,
1892; oil on canvas, 116x90; Musée d'Orsay.

PHILADELPHIA (UNITED STATES)
The Bathers,
1884-87; oil on canvas, 115x170;
Museum of Art.

PITTSBURGH (UNITED STATES)
The Garden at Rue Cortot,
1876; oil on canvas, 155x100; Carnegie Institute.

PORTLAND (UNITED STATES)
Sails on the Seine at Argenteuil,
1873; oil on canvas, 50x65; Museum of Art.

PRAGUE (CZECH REPUBLIC)
Lovers,
1875; oil on canvas, 175x130; Národni Galerie.

SAO PAOLO (BRAZIL)
Bather with a Griffon,
1870; oil on canvas, 184x115; Museu de Arte.

TOKYO (JAPAN)
Parisiennes Dressed as Algerians,
1871-72; oil on canvas, 157x130;
National Museum of Western Art.

Path in a Wood
1880; oil on canvas, 56x46;
National Museum of Western Art.

VIENNA (AUSTRIA)
Bather (After the Bath),
1876; oil on canvas, 93x73; Neue Galerie.

WASHINGTON D.C. (UNITED STATES)
Dancer,
1874; oil on canvas, 142x93; National Gallery.

Girl with Watering Can,
1876; oil on canvas, 100x73; National Gallery.

Henriette Henriot in White,
1876; oil on canvas, 70x55; National Gallery.

The Luncheon of the Boating Party,
1881; oil on canvas, 129.5x172.5;
Phillips Collection.

WILLIAMSTOWN (UNITED STATES)
Blond Bather,
1881; oil on canvas, 81x65;
Sterling and Francine Clark Art Institute.

WINTERTHUR (SWITZERLAND)
Seated Bather Drying Herself,
1888; oil on canvas, 65x54;
Sammlung Oskar Reinhart.

ZURICH (SWITZERLAND)
Alfred Sisley,
1868; oil on canvas, 81x65;
Stiftung "Sammlung E. G. Bührle".

BIBLIOGRAPHY

The following list furnishes some guides useful for obtaining the first instruments of orientation and information on the artist.

1863 C. Baudelaire, *Le Peintre de la Vie Moderne*, Paris [1981, Torino]

1876 G. Rivière, *L'Exposition des Impressionnistes*, in "L'Impressionniste", Paris

1880 E. Zola, *Naturalisme au Salon*, in "Le Voltaire", Paris

1883 J. K. Huysmans, *L'Art Moderne*, Paris

1884 O. Mirbeau, *Notes sur l'Art. Renoir*, in "La France", Paris

1921 G. Rivière, *Renoir et ses Amis*, Paris

1933 L. Venturi, *Renoir*, in *L'Arte*

1939 *Scritti di Renoir*, in L. Venturi, *Les Archives de l'Impressionnisme*, Paris, New York

1935 A. C. Barnes, V. de Mazia, *The Art of Renoir*, Merion

1947 G. Jedelicke, *Renoir*, Bern

1954 *Renoir*, Geneva, Paris, New York D. Rouart, *Renoir*, Geneva

1961 J. Renoir, *Pierre-Auguste Renoir, mon père*, Paris

1967 *Renoir*, exhibition catalogue, New York

1972 E. Fezzi, *L'Opera completa di Renoir*, Milano

1982 *Renoir un quadro per un movimento*, exhibition catalogue, Trento

1985-86 *Renoir*, exhibition catalogue, London, Paris, Boston

1993 M. T. Benedetti, *Renoir*, in "Art Dossier", Firenze

Chagall
The Falling Angel

Dali
The Persistence of Memory

Kandinsky
The First Abstract Watercolour Painting

Leonardo
The Last Supper

Manet
Le déjeuner sur l'herbe

ONE HUNDRED PAINTINGS:

every one a masterpiece

The Work of Art. Which one would it be? ...It is of the works that everyone of you has in mind that I will speak of in "One Hundred Paintings". Together we will analyse the works with regard to the history, the technique, and the hidden aspects in order to discover all that is required to create a particular painting and to produce an artist in general.

It is a way of coming to understand the sensibility and personality of the creator and the tastes, inclinations and symbolisms of the age. The task of "One Hundred Paintings" will therefore be to uncover, together with you, these meanings, to resurrect them from oblivion or to decipher them if they are not immediately perceivable. A painting by Raffaello and one by Picasso have different codes of reading determined not only by the personality of each of the two artists but also the belonging to a different society that have left their unmistakable mark on the work of art. Both paintings impact our senses with force. Our eyes are blinded by the light, by the colour, by the beauty of style, by the glancing look of a character or by the serenity of all of this as a whole. The mind asks itself about the motivations that have led to the works' execution and it tries to grasp all the meanings or messages that the work of art contains.

"One Hundred Paintings" will become your personal collection. From every painting that we analyse you will discover aspects that you had ignored but that instead complete to make the work of art a masterpiece.

Federico Zeri

Coming next in the series:

Matisse, Magritte, Titian, Degas, Vermeer, Schiele, Klimt, Poussin, Botticelli, Fussli, Munch, Bocklin, Pontormo, Modigliani, Toulouse-Lautrec, Bosch, Watteau, Arcimboldi, Cezanne, Redon

Raphael
School of Athens

Rembrandt
Supper at Emmaus

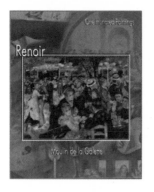

Renoir
Moulin de la Galette

Rubens
Garden of Love

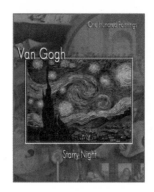

Van Gogh
Starry Night